THE BAY AREA COLLECTS: ART FROM AFRICA, OCEANIA, AND THE AMERICAS

Thomas K. Seligman *Kathleen Berrin*

The Fine Arts Museums of San Francisco

This catalogue was published in conjunction
with an exhibition organized by The Fine Arts
Museums of San Francisco and exhibited at the
M.H. de Young Memorial Museum
July 3, 1982 - October 3, 1982

Dimensions are given in both inches and centimeters,
height preceding width preceding depth.

We wish to thank William Fagg for comments on attributions
in the African section.

CONTENTS

This catalogue is dedicated to the memory of two beloved Bay Area collectors:

William Russel Bascom (1912-1981), whose knowledge, enthusiasm, and love for the art and folklore of non-Western societies was an inspiration to us all.

Clyta Loran (1910-1982), whose discerning eye and forthright appreciation of art from Africa, Oceania, and the Americas helped build the Loran Collection, one of the foremost collections in northern California.

FOREWORD

Art objects from Africa, Oceania, and the Americas were part of the charter collections of the M.H. de Young Memorial Museum. The creation of a department and permanent gallery in the early 1970s signaled our renewed commitment to these collections, which had expanded considerably since the founding of the Museums. With the merger of the de Young and California Palace of the Legion of Honor in 1972, several very important Pre-Columbian holdings of the Legion were integrated into the collections soon to be displayed at the de Young Museum. Since 1928 there have been continuous temporary exhibitions of this art in both Museums; so it was with great pleasure that we accepted the proposal of the Board of Directors of the Friends of Ethnic Art to develop an exhibition of African, Oceanic, Pre-Columbian, and American Indian art from the numerous private collections in the Bay Area.

From the outset it was clear that the criterion for selection of objects should be aesthetic merit, rather than considerations of balanced cultural representation. The content of the exhibition therefore reflects the particular interests of current Bay Area collectors and the strengths of their collections.

The Friends of Ethnic Art membership, its board, and president, Spring Kraeger-Stosick, were invaluable for their continuing support of the project. Various individuals contributed to the research for this catalogue and exhibition. We are grateful to all of them for their time and knowledge. We owe special thanks to Elayne Marquis, the Friends of Ethnic Art exhibition liaison; Ruth Franklin, Ellen Werner, and Leroy Cleal for special research; and Ernest B. Ball, Tish Brown, Gregory Ghent, Spring Kraeger-Stosick, Robert Lauter, Elayne Marquis, Alec Merriam, Stacy Schaefer, and Barbara Winther, who helped the Museums' staff conduct the interviews and research the objects selected for exhibition.

At this time when private support for museum projects is essential, we are extremely grateful to the many businesses and individuals who gave generously to this project. Macy's California took the responsibility for all costs for the production of this handsome catalogue. Macy's support of important cultural projects in the Bay Area keeps it in the forefront of businesses whose activities and commitment continue to enrich our community. We also wish to thank the following individuals for their generous support of the project: Dr. Keith Anderson, Ernest B. Ball, Mr. and Mrs. Robert Bransten, Mr. and Mrs. Marc Franklin, Alfred Fromm, Francis Goldsmith, Gulliver's Travel, Mr. and Mrs. John Haley, Senator and Mrs. S. I. Hayakawa, Dr. and Mrs. Michael Heymann, Mr. and Mrs. Erle Loran, Mr. and Mrs. James J. Ludwig, Mr. and Mrs. J. Alec Merriam, Morgan Equipment Company, Ed Nagel, Sue Niggeman, Dr. and Mrs. Ralph J. Spiegl, Dwight V. Strong, and Mr. and Mrs. Klaus Werner.

Thomas K. Seligman, Curator in Charge of the Department of Africa, Oceania, and the Americas, was responsible for the overall conception and direction of the project; Kathleen Berrin, Associate Curator, served as project co-organizer. Their joint efforts resulted in this splendid exhibition and catalogue. In the course of research it became evident that several exhibitions could be created from the number of outstanding objects in private collections in the Bay Area. For this exhibition, we chose to focus primarily on sculpture and other three-dimensional objects that have been made and used by traditional cultures. Many beautiful textiles, costumes, and more contemporary objects could not be included because of the lack of available gallery space.

The installation has been designed by Bob Davis, the graphic design was done by Ron Rick, and the objects were installed by our technical crew supervised by Bill White. The results are the product of their skillful work and collective talents. We especially wish to thank Ann Heath Karlstrom for her meticulous attention to editing and Jetty Lynch for her care and accuracy in preparing the manuscript for the catalogue. Ruth Franklin and Leroy Cleal of the Friends of Ethnic Art also made valuable and much appreciated contributions. Accompanying programs for the exhibition have been sponsored by the Friends of Ethnic Art and we are grateful to Pat Goyan for organizing them.

Of course, no exhibition of this sort would be possible without the generosity of the lenders who agreed to part with their objects temporarily to share them with a broader public. It is their hope and mine that these beautiful objects will be an inspiration to others to join in the rewarding adventure of collecting fine works of art.

Ian McKibbin White
Director of Museums

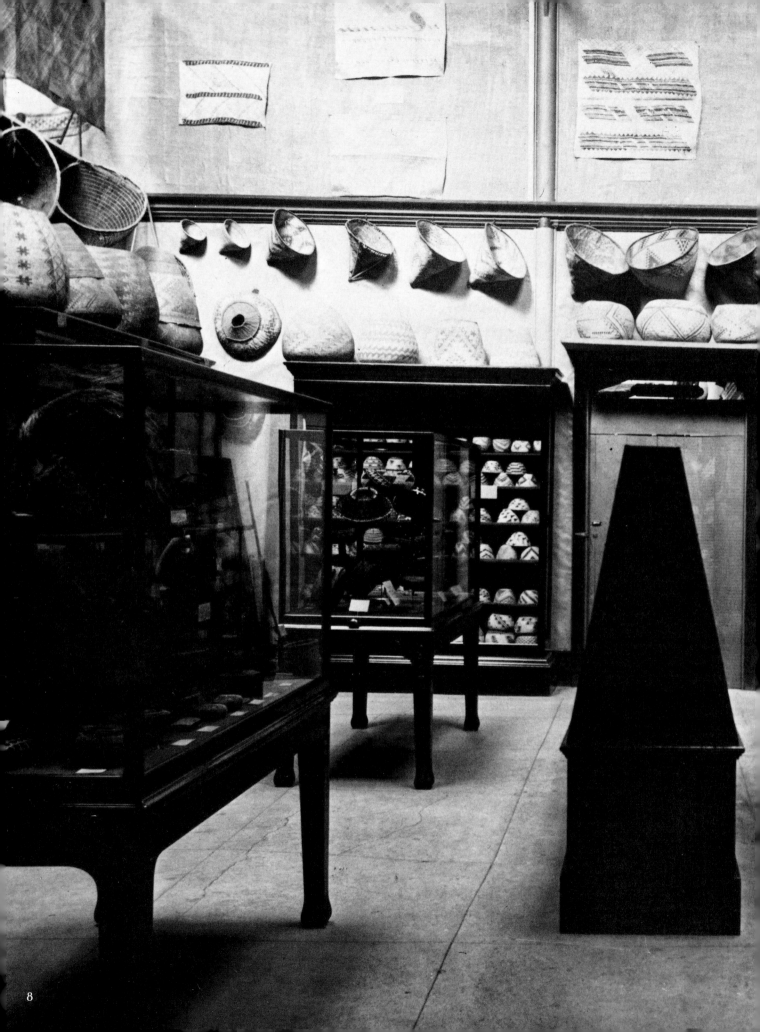

COLLECTING THE ART OF AFRICA, OCEANIA, AND THE AMERICAS: A BAY AREA PERSPECTIVE

Collecting is an ancient human activity, and there may be as many motives for it as there are collectors. The activity has been described as an urge, a passion, even a disease; and the reasons for collecting must stem from very deeply felt motivations—visceral, visual, intellectual, and social. Among all who participate there are distinctions between the serious collector, the casual amateur, and the one who buys for financial investment. A discussion of collecting in the Bay Area certainly must consider all of these, but a museum department devoted to collecting and exhibiting fine art is obviously concerned primarily with the serious collector of fine art—in this case, from the cultures of Africa, Oceania, Pre-Columbian Mesoamerica and South America, and native North America.

The difference between an art object and an ethnographic one depends upon one's viewpoint and the object itself, and though the two categories are not mutually exclusive, it is our desire and mandate to deal with the former. Within the vast corpus of objects produced by any culture, only limited numbers are of significant aesthetic quality—and those are the objects most sought after by the serious collector and art museum. While there are numerous differences between a private collector and a museum, the two often exist in an interdependent and mutually supportive relationship.

Collectors of this kind of art, in the past simply referred to as "primitive,"[1] have become increasingly concerned with the relationship of non-Western pre-industrial art to Western aesthetic, intellectual, and cultural values. Many hope that a better understanding of ourselves and our relationship to humankind both past and present can occur through the exploration of these art forms. The personal search for such answers, at whatever level, is surely one of the primary concerns of the serious collector.

This exhibition of art from Africa, Oceania, and the Americas presents to the public for the first time a number of unusually fine objects from private collections in the Bay Area. It also provides the opportunity to explore the local history of collecting such objects. Since little of direct relevance has been written on the subject, we began the project by interviewing a number of collectors and other knowledgeable individuals who have been actively involved in this field.[2] From this process has evolved a profile of the history and character of Bay Area collections of art from Africa, Oceania, and the Americas formed in the past hundred years.

Early display of Indian baskets, M.H. de Young Memorial Museum.

THE EARLY YEARS: INDIANS AND PEOPLES OF THE SOUTH SEAS

Little of a specific nature can be said about the extent of private collections of "art" from Africa, Oceania, and the Americas in the Bay Area during the last decades of the nineteenth century and the first few decades of this century. San Francisco and the Bay Area comprised a rapidly developing urban area with an important port giving access to the entire Pacific Basin. It was also the terminus of the transcontinental railroad allowing for the rapid movement of people, goods, and ideas to and from the East Coast. Much wealth emerged from the Gold Rush and the economic boom that followed.

Northern California and the rest of the northwest coast were among the few areas in the United States where indigenous Indian populations remained late into the nineteenth century. While these groups were in a severe state of economic and social decline, they still held an attraction for men such as Charles Wilcomb and Alfred Kroeber, who tried to understand and document Indian life by forming collections of objects before the way of life was lost forever.

Charles Wilcomb, one of the earliest pioneers in field collecting on the West Coast,[3] surely must be designated as a collector *par excellence*, having personally gathered over 10,000 objects in his lifetime.[4] Wilcomb's collecting motivations were not for investment purposes; it was his belief that museums should provide educational experiences for the public and that he, a man dedicated to museums, should document the Indian way of life which was fast disappearing. As the first curator of the Golden Gate Park Museum (precursor to the de Young Museum), Wilcomb energetically explored old Indian *rancherias* in north central California to amass a collection of objects for the museum during the years 1895-1904. Expecting to be reimbursed for his efforts, he paid for virtually all of what he obtained from his personal salary. The ensuing misunderstanding with city officials and the Park Commission resulted in Wilcomb's resignation. Wilcomb took his basket collection to Pittsburgh, where he went to work for a private collector named Robert Hall and they subsequently developed the Hall Museum.[5]

In 1908 Wilcomb returned to California and was invited by the mayor of Oakland to develop the Oakland Public Museum.[6] For seven years Wilcomb served as Oakland's first curator, continuing to build a collection of Indian artifacts and American colonial materials for that institution.

Wilcomb was an independent person who worked with no apparent apprentices or followers, and the direct role he played in stimulating others to collect seems to have been minimal. Yet the Wilcomb collections that exist in Northern California today are very important.[7] He was also instrumental in convincing people to donate their California Indian

9

and South Pacific collections to the Oakland Public Museum, the donations materializing even in the years after his tenure.[8] Late in life Wilcomb had been an active participant in the Panama Pacific International Exposition of 1915 (held in San Francisco) which celebrated the opening of the Panama Canal. He may therefore be credited with Oakland's acquisition of the Philippine artifacts exhibited at the Exposition which are still among their permanent holdings.

Predating Wilcomb and his efforts for Northern California public institutions were the collections taking shape at the California Academy of Sciences, which had been founded in 1853 in San Francisco. While most of the Academy's collecting was in the field of natural history, there were ethnographic objects and California Indian artifacts—or "curiosities"[9]—which were worked on by Alfred Kroeber when he came to the University of California at Berkeley in 1901. Although Theodora Kroeber writes that the Academy's Indian collections were "not large. . .within six weeks Kroeber had them firmly in hand,"[10] there is really no way to estimate the number of these early holdings or the accuracy of her recollection. Tragically, virtually nothing is known about these early collections at the Academy, for nearly all of them (save the Polynesian lithic material), including records and library, were destroyed by the fire that followed the 1906 earthquake.[11]

One notable individual who significantly shaped the history of public collections in this area was Phoebe Apperson Hearst. She provided the financial support and incentive for the development of the anthropology department of the University of California at Berkeley and invited Alfred Kroeber to serve as a professor, curator, and collector for the University in 1901. With her funding, Kroeber was able to do field collecting and other anthropological work with his students in Northern California Indian areas. Hearst financial support declined with the collapse of the Comstock mines around 1906-07, but not before Phoebe Apperson Hearst supported the important Uhle expedition in Peru and others in Egypt and the Mediterranean area which served to enrich the University's holdings. She also provided the funds for the University to purchase some valuable Eskimo and Northwest Coast Indian collections during these early years. In 1911 the University of California's Museum of Anthropology, forerunner of the Robert H. Lowie Museum of Anthropology, opened to the public in San Francisco's Parnassus Heights. Alfred Kroeber was its curator.

Jack London, in the one energetic collecting spurt of his life relevant to this essay, deserves some mention here. In 1908 he traveled (as part of a larger trip) to some little-known parts of Polynesia where the natives reportedly showered him with gifts of "curiosities" and souvenirs. London was not a selective collector—he made no attempt to get any type of scientific data about what he was receiving—but the number of objects he shipped back in this single year is estimated at between 300 and 400.[12] These included such things as large bowls, jewelry, shells, fish hooks, tapa cloth, tourist curios, oars, spears, and even a large war canoe (now missing). While much of what he collected is now dispersed or destroyed, a selection may be seen at the Jack London State Park in Glen Ellen, California.

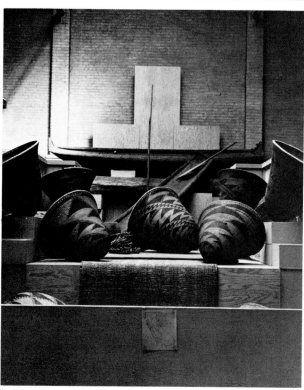

Duke Wellington display of California Indian baskets at the Power House, Berkeley campus, University of California, 1950-51. Photo courtesy of The Bancroft Library.

On January 20, 1921, the M.H. de Young Memorial Museum was dedicated to the City of San Francisco. The story of the de Young Museum seems to typify that of many of this country's civic museums. Inspired by the Chicago International Exposition of 1893, M.H. de Young, owner of the *San Francisco Chronicle* and a prominent civic leader, became the moving force behind the re-creation of major parts of the Chicago extravaganza in San Francisco, with some special additions. Known as the California Midwinter International Exposition of 1894, it was located in temporary pavilions in what is now the Concourse area of Golden Gate Park. The Exposition was overwhelmingly popular, and many of the exhibited objects that remained after it closed formed the basis for a new museum that M.H. de Young organized to replace permanently the Fine Arts

Pavilion of the Fair. Among the collections remaining from the Midwinter Fair was an important core of objects from the peoples of the South Pacific. There were also important pieces from California and Northwest Coast American Indians.

During the first two decades of this century, it became fashionable in California to collect "curiosities" and trinkets from different parts of the world. Indian artifacts, particularly baskets, pottery, and arrowheads, were readily available, ever-varied, and more or less reasonably priced. They were perfect collector's items and many people began to form collections, sometimes in competition with one another.[13]

Although many of the objects were beautiful, the great majority of people who were involved in obtaining them were not building "art" collections or even documenting a dying way of life. Rather, they were acquiring "collectables" for decorative ambience, an activity which seems to have been fueled by a romanticism about and nostalgia for California's wild and exotic past.[14] At this time there were dozens of shops selling Indian curios in the Bay Area. And in Northern California the craze for Indian-ness became somehow blended with the post-Victorian aesthetic, as prominent displays of baskets, arrowheads, and bric-a-brac of all types were arranged in collectors' homes.[15] The craze for things Indian gradually subsided in the period following World War I.

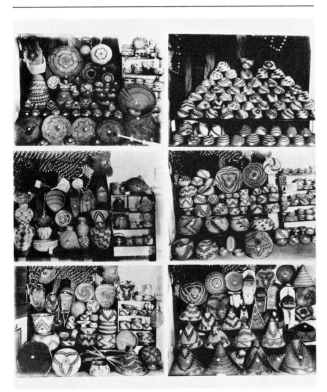

Indian baskets from the personal collection of Mae Helene Bacon Boggs: Photo courtesy of the California Historical Society, San Francisco.

In 1927-28 the pioneering work by Franz Boas called *Primitive Art* became available, and gradually scholars, collectors, and artists began to see the aesthetic importance of art from non-Western peoples.[16] Although in the thirties there seems to have been a collecting hiatus in the Bay Area, there were still a few wealthy individuals who were sponsoring or conducting collecting expeditions. Templeton Crocker, a San Francisco socialite and financier, made long South Seas cruises in his yacht during the 1930s, bringing back on his later trips objects from New Guinea and the Trobriand Islands, some of which were later donated to the de Young Museum.[17]

The Pacific Basin continued to hold increasing importance for America, and particularly for San Francisco as the Gateway to the Pacific. This was clearly expressed by the 1939 Golden Gate International Exposition on Treasure Island, whose theme was "Cultures of the Pacific." The Pacific cultures represented in the exposition as defined by the official catalogue were China, Southeast Asia, Japan, Northwest Coast Indian, Pacific Islands, South America, and Middle America. To represent these cultures, the exposition featured a spectacular pavilion which Alfred Kroeber and a number of other distinguished scholars (those most relevant to our subject are Frans Blom, Peter H. Buck, Miguel Covarrubias, Erna Gunther, and Herbert J. Spinden) helped to plan, using objects from major public and private collections throughout the world.

With good reason, during the late nineteenth century and the early decades of the twentieth, most institutional and private collecting interests in the Bay Area focused on North American and South Pacific objects. Although most collections were not built primarily for their aesthetic merit but as "curiosities," numerous outstanding pieces were collected from these two major culture areas during this period. With few exceptions it was not until the middle of the twentieth century that Bay Area collecting turned seriously to Pre-Columbian and African objects.

THE MIDDLE YEARS AND
THE BERKELEY COLLECTORS

Soon after the turn of the twentieth century, the artists Vlaminck, Derain, Braque, and Picasso, in their quest for liberation from the confines of academic art, "discovered" African art. In the next decades "primitive" art became better known and continued to be an inspiration to a number of artists, but at first the interest in African masks and figures as art was confined only to the most avant-garde.

The art and art history departments of the University of California at Berkeley were growing, and some of the newer members of the faculty were among this avant-garde. Two of the most notable were Erle Loran and John Haley. Both men were artists who had lived and studied in Europe in the

late 1920s, where they developed a keen interest in African and Oceanic art.[18] Haley came to the University of California in 1930, Loran followed in 1936, and both, with the active collaboration of their wives, continued collecting art, especially African, for the aesthetic pleasure and visual stimulation that it provided. Other artists connected with the University, in some cases inspired by Loran and Haley, also began collecting—notably Ed Taylor, Henry Schaffer-Simmern, Felix Ruvolo, and Millard Sheets. In later years, faculty members in other departments also became interested collectors of "primitive" art.

What is interesting about this collecting activity in Los Angeles, Berkeley is that many types of non-Western art were being collected, much of it coming from dealers in Los Angeles, the Southwest, New York, and Europe. While most of the early Berkeley collectors focused on African art, they acquired aesthetically pleasing objects from all over the world. Although each knew of the others' interests and activities, they essentially pursued collecting alone. There was little of the competition for objects or for social status that has occurred in some other cities. Virtually none of these artists/teachers (an important exception to follow) used their collections for significant teaching purposes, nor did any of them make trips to Africa or the Pacific to find objects or experience the cultures from which the objects came. They all seemed to collect quietly and discreetly but with similar motivations, caring little about how the objects in their collections had been created and used within their original context, in fact disdaining such "cultural interference," as John Haley has termed it, and seeking objects solely for their formal or aesthetic qualities.

An extremely influential, somewhat eccentric, but passionate Berkeley collector in the 1940s and 1950s was Winfield Scott Wellington, commonly known as "Duke." He was an architect, as well as a professor in the Department of Decorative Arts at the University of California, who amassed a vast personal collection of objects from all parts of the world, including important holdings of Southwest and Northwest Coast Indian material.[19] Wellington taught a design course entitled "A Survey of Expressions in Various Materials" in which he drew upon countless inspirational examples from his own collection. His enthusiastically attended lectures were augmented once a week by sessions in which "hundreds of items" were brought for students to study and handle as superb examples of design.

Wellington assembled exhibitions of non-Western art at the Power House (the old central steam plant on the Berkeley campus), drawing from the anthropological collections of the University which were all in storage. He worked with Kroeber to design the Andean Room of the Federal Pavilion of the Golden Gate International Exposition and did a temporary exhibition of Southwest Indian art in 1953 at the de Young Museum. His designs, at least for exhibitions at the Power House, seem to have been display extravaganzas. Objects were chosen for their formal qualities alone and then positioned or grouped for startling visual drama.[20]

Wellington also juried the Indian arts and crafts shows each year in Gallup, New Mexico. He loved beautiful objects and devoted his entire life to communicating this love to his students. His contacts with Berkeley collecting peers seem to have been minimal. When he became ill in the sixties he began to sell off parts of his collection; the great majority of his Indian objects were sold to an out-of-state dealer.

During the period between 1930 and the late 1950s there seems to have been no major dealer or gallery in the Bay Area consistently offering art objects from Africa, Oceania, and the Americas. Of course, there were items—especially Indian baskets—to be found in curio and antique shops and occasionally in boutiques or stores such as Gumps, but there was no real source for quality objects in Northern California. Serious collectors, such as the Berkeley professors, usually obtained their best pieces from dealers in Los Angeles, New York, and the Indian trading posts in the Southwest. Occasionally they would even purchase them in Europe.

An increased interest in Pre-Columbian art in the Bay Area was caused by the energetic activity of the Stendahls, particularly Earl Stendahl in Los Angeles.[21] Certainly the most important West Coast dealer of his day, "Old Man" Stendahl supplied much of the great Pre-Columbian art to collectors all over the United States and Europe, organizing special exhibitions for galleries and some museums. Stendahl used to sell to many Bay Area collectors directly or through the Rabow Gallery or Gump's in San Francisco, where he put pieces on consignment. He was also a friend of a local personality, Bill Pearson, who had spent several years in the 1940s living in Mexico riding as the jockey for the President of Mexico.

Pearson had a long-standing collecting interest in American Folk art, especially quilts, and during his stay in Mexico learned much about Pre-Columbian art. When he returned to Los Angeles he joined a number of friends, all of whom shared an interest in collecting "primitive" art. Among them were Ralph Altman, Bill Moore, Millard Sheets (who then was living in Los Angeles), Earl and Alfred Stendahl, Walter Arensberg, John Huston, and Billy Wilder. To finance his collecting interest, Pearson had established several galleries in various parts of California before opening his gallery on Union Street in San Francisco in 1957, specializing in Pre-Columbian and American folk art.

Pearson's tastes and personality seem to have

influenced several Bay Area collectors who were friends and traveled with Pearson on collecting trips to Mexico in the early sixties. They also made purchases from the Stendahls in Los Angeles. Gradually their interests broadened to include African art, which Pearson was handling in San Francisco as were the major dealers Harry Franklin, Edward Primus, and David Stuart in Los Angeles, and numerous New York dealers.

African art does not seem to have entered the collections of many Bay Area institutions until the 1950s, falling considerably on the heels of North American Indian, Oceanic, and Pre-Columbian acquisitions. In 1957, a man arrived who made all the difference: William R. Bascom, who assumed directorship of the then re-named Robert H. Lowie Museum of Anthropology on the Berkeley campus. A multi-talented man, especially esteemed for his work with the Yoruba of Nigeria, Bascom did much to increase the museum's African holdings during the period of his directorship (nearly twenty-two years!).[22] Art lovers especially remember the *African Art* exhibition of 1967 which featured a number of objects he collected on trips to Africa.

During the middle years of this century, then, most of the people in the Bay Area collecting art from Africa, Oceania, and the Americas were living in Berkeley and were most often connected with the University. There seems to have been much less activity in San Francisco proper. While people were collecting in all areas, African and Pre-Columbian seemed to hold the greatest attraction. Those in Berkeley generally collected in isolation and for the sheer pleasure of artistic inspiration received from the objects. There was little interest in the peoples who made them, a situation which was to reverse itself in the following decades.

THE 1960s AND BEYOND: PEACE, LOVE, AND "ETHNIC ARTS"

In the late 1950s in San Francisco, a number of American subcultures developed that had strong interests in non-Western values and art. The Beatniks were followed in the 1960s by the Hippies, whose life-style reflected a rejection of what they perceived as an increasingly technological and dehumanized American value system and a heightened awareness of the simpler, more "natural" life-styles of non-Western cultures. Also at this time, the Peace Corps was enlisting young people from the colleges and universities in the Bay Area to spend two years living in generally remote villages of the developing nations. Many of these volunteers worked on arts and crafts projects in an effort to help market and preserve aspects of the traditional cultures. Finally, as travel became less expensive, many people visited countries that had been relatively inaccessible in the past, bringing back souvenirs of their visit often in the form of art objects.

The Bay Area again flourished, as it had several times in the past, as a center of creative artistic activity; and the influx of art from Africa, Oceania, and the Americas became linked with the emergence of a number of artists who were inspired by the forms and techniques used in "ethnic art." Also, many people began to adopt "ethnic dress" and design their domestic environments using folk arts and crafts from the non-Western world which were becoming inexpensively available through such outlets as Cost Plus Imports, which first opened in San Francisco in 1958.

Parallel and complementary to this trend was the rise or expansion of galleries devoted to crafts and fine "ethnic art" which served as a source for the increasing number of serious collectors. Marian Davidson's shop on Union Street, which had existed since 1953, continued to feature contemporary Southwest Indian jewelry and textiles until the early seventies. Marjorie Anneberg, whose gallery operation spanned 1964-1981, developed sale exhibitions of crafts (especially textiles) and for years had been working to build a folk art and craft museum for the Bay Area. Bill Pearson moved his gallery to Sacramento Street across from West of the Moon which Susan Smith and Fred King had originated in 1971; both galleries continue to carry a mixture of folk art, textiles, and sculpture, with West of the Moon specializing in American Indian objects and Pearson continuing to carry objects from diverse areas. James Willis also opened his gallery in Sausalito at this time. Gradually the department stores have also become involved. Saks Fifth Avenue presented an African show in 1976. Gump's and Macy's have had several major sales exhibitions of art from Africa and New Guinea, and the Macy's Amazon exhibition which opened in January of this year illustrates a continued interest in "ethnic art."

As the population of the Bay Area soared during the sixties with the influx of people from other parts of the United States, the Pacific Basin, and Central and South America, interest in "ethnic art," or at least "ethnic" peoples, broadened. The decade of the sixties was dedicated to social causes, civil rights, and protests against the war in Vietnam; it was a time oriented more toward people than objects, although serious collectors continued to acquire.

Departments of Africa, Oceania, and the Americas (sometimes called "primitive art" departments) were emerging in major art museums throughout the country, but it was not until the appointment of Ian McKibbin White as director of The Fine Arts Museums of San Francisco in 1970 that the de Young Museum began to develop the impetus to create a special department for these collections (previously a

part of the Department of Decorative Arts) and a permanent gallery for their display.[23]

One of the first tasks undertaken by Ian White was to return the Museums' collections of art from Africa, Oceania, and the Americas (then in storage) to full public view. It was through his commitment that the Museums developed the means to create the necessary plans and support systems for the realization of this project.

The first curator of the de Young's Department of Africa, Oceania, and the Americas was Jane Powell Dwyer, a Pre-Columbian specialist who had been Curator of Primitive Art at the Brooklyn Museum. Dr. Dwyer did much of the fundamental work required to prepare and assess the de Young's collection. When she left to direct the Haffenreffer Museum at Brown University in 1971, she was succeeded by Thomas K. Seligman, who had just returned from Liberia and whose specialty was African art.[24] Soon after, Kathleen Berrin, whose primary interest area was Oceanic, joined the staff; and on May 23, 1973, after much hard work and the commitment of many, 10,000 people participated in the opening of the new permanent gallery. In the years following, a program of special exhibitions was presented, many focusing on particular art collections or cultural areas. Noteworthy among them were the exhibitions of the *Louis Allen Collection of Aboriginal Australian Art* (1974), *African and Ancient Mexican Art: The Loran Collection* (1975), and *Fire, Earth, and Water: Sculpture from the Land Collection of Mesoamerican Art* (1976).[25] It seems logical to expect that the public presentations of these large and distinguished local private collections served to inspire other new residents in the Bay Area to develop their collecting interests, and interviews with several important collectors attest to this inspiration.

In the 1970s other Bay Area museums were devoting more attention to this area. The California Academy of Sciences revived its previous interest in anthropology with the opening of the Wattis Hall of Man in 1976, followed by a series of important exhibitions focusing on the material culture of various world areas. The Robert H. Lowie Museum of Anthropology[26] continued its tradition of presenting focused exhibitions from its collections as well as loaning some of its most beautiful and important objects for display in the newly constructed University Art Museum when Peter Selz was director. The Lowie later began lending objects to other museums that had fewer resources. The Oakland Museum presented California Indian objects. The Stanford University Museum devoted some space to exhibiting "ethnic" art, and the Stanford Art Gallery presented a special exhibition on African art.

Probably the most influential gallery of the 1970s was the James Willis Gallery, which consistently organized special exhibitions of African and Oceanic

fine arts (including Indonesian) and became a catalyst for a number of newer collectors in the Bay Area. Willis joined Los Angeles artist/dealer Mort Dimondstein and later shared his gallery space with Peter Wengraf of London's Arcade Gallery. Thus, many more fine objects, especially African, were coming to San Francisco than ever in the past.

In 1976 the Friends of Ethnic Art originated in San Francisco as a private non-profit organization devoted to furthering the interest in and understanding of "ethnic" arts. As this group developed, it presented educational programs for its own members and for the public. Some were offered in conjunction with local museums and academic institutions. It is in this realm of activity that the Friends of Ethnic Art provided the major stimulus for the creation of this catalogue and accompanying exhibition.

In the last twenty years, as art from Africa, Oceania, and the Americas became more popular and remote areas of the world more accessible, Bay Area people began to travel directly to the places that make and use this art. Of course, for many years people had visited the major Pre-Columbian archaeological sites of Mexico and Peru and the surviving Southwest Indian cultures, but it wasn't until the late 1960s that large numbers of sightseers traveled to Africa, Melanesia, or Indonesia to experience the cultures that intrigued them. In recent years, The Fine Arts Museums and the Academy of Sciences have conducted several trips for their members which have furthered the interest in these arts, and James Willis has accompanied several trips to West Africa.

COLLECTORS AND COLLECTING: BAY AREA ATTITUDES

Having lived and worked with collectors of African, Oceanic, Pre-Columbian, and American Indian art in the Bay Area for the past decade, we feel that there continues to be something unique to collectors in this area. Our local research has tended to sharpen this belief, although it will remain somewhat speculative until inquiries are carried out in other collecting communities to gather comparative information.

Virtually everyone we spoke with agreed that the support for the visual arts in general has been very limited and that there has been very little collecting activity in the arts of Africa, Oceania, and the Americas relative to the Bay Area's population and presumed sophistication. Most people also agree that this area is a center of great creative activity with little public awareness. Most dealers and gallery owners maintain that very little of their business is done in San Francisco and none could have survived had they had to depend on a local clientele.

In the interviews reflected in this essay, people responded to questions about these incongruities with passionate, fascinating, but by no means conclusive answers. Many noted a cultural smugness and complacency due to the beautiful physical environment of the Bay Area; some cited hedonistic attitudes that lead people to spend money on ephemeral pleasures; some mentioned the area's innate conservatism and preference for "safe" cultural activities; and some pointed to our predilection for the pretty or decorative, epitomized by Victorian architecture, rather than the deeply penetrating response that "ethnic" art can inspire.

In spite of the relative scarcity of collectors of the art of Africa, Oceania, and the Americas in the Bay Area, it is still possible to make some general remarks about what characterizes Bay Area collecting. Early on, the collections were mainly from the Indians of the western United States and select cultures of the South Pacific, and objects were collected as "curiosities" or tribal artifacts—not as works of art. More recently, as the objects shown in this catalogue and exhibition make clear, the emphasis has switched to African and Pre-Columbian art, and private collections are formed primarily from aesthetic concerns. Present-day Bay Area collections seem to be uniquely personal. They haven't been formed on the basis of what is currently chic, or from a posture of social competition, or for financial gain. Collectors in the Bay Area have generally followed their own instincts, predilections, and passions to collect what truly pleases and excites them.

Those who have persevered and have formed or guided the creation of serious collections of arts from Africa, Oceania, and the Americas deserve to be recognized for their efforts. It is because of their individuality, independent standards, and lack of interest in following fads that Bay Area collectors have made some very wise choices. We are pleased to present this representative display to the public.

NOTES

1. This term is no longer widely used because of negative connotations, thus leaving a dearth of short reference terms. In this essay, quotation marks denote terms that reflect the bias or point of view of the historical period.

2. The authors wish especially to thank Max Alfert, Marjorie Anneberg, Joan Bacharach, Ernest B. Ball, Berta Bascom, Ruth Boyers, Charles Campbell, Herschel Chipp, Leroy Cleal, Marian Davidson, Lawrence E. Dawson, Marc and Ruth Franklin, Melinda Young Frye, L. Thomas Frye, John and Monica Haley, Kay Jenkins, Fred King, Russ Kingman, Erle and Clyta Loran, Allen Maret, Gail Merriam, Robert Neuhaus, Frank A. Norick, Billy Pearson, Louise Revol, Ed Rossbach, Alfred Stendahl, Dorothy Washburn, Katherine Westphal, and James Willis for information obtained in interviews. We are also grateful to Lawrence E. Dawson, Ruth Franklin, Melinda Young Frye, Erle Loran, and Louise Revol for critical comments on the manuscript.

3. Individuals working for some of the major museums in Germany and natural history museums in the eastern United States, such as the Peabody Museum of Archaeology and Ethnology at Harvard University, The American Museum of Natural History, and the Smithsonian Institution, had been collecting here slightly earlier.

4. Personal communication from Melinda Young Frye to Kathleen Berrin, September 1981.

5. For a fuller explanation of the Hall Collection and Wilcomb's efforts in Pittsburgh, see Frye (1977 and 1979) in bibliography following essay.

6. The Oakland Public Museum was one of the three museums that merged in 1969 to form The Oakland Museum.

7. These include the collections of The Oakland Museum and those now owned by the State of California; the latter include objects that had been intended originally for the Golden Gate Park Museum.

8. Personal communication from Louise Revol, Associate Curator of History, The Oakland Museum, to Kathleen Berrin, January 1982.

9. "Curiosities" were man-made items from any exotic part of the world which were sometimes considered a kind of art but were never heightened to the status of European-made objects. The term "curiosities" was in learned usage up to the turn of the century and in lay usage well after that according to Lawrence E. Dawson, hence our use of it here.

10. See Theodora Kroeber (1970), p. 54. Soon after his arrival, Alfred Kroeber had tried to enlarge the Academy's holdings by personal field collecting, but like Wilcomb he was disillusioned by lack of institutional support and briefly returned to the East.

11. While the Academy's ethnographic collections grew during the fifties and sixties with the development of the natural history halls, institutional interest in actively pursuing such collections was not seriously renewed until the 1970s with plans for the Wattis Hall of Man. Today, the Academy's collection strengths lie in the areas of western American Indian basketry, Alaskan Eskimo artifacts, Peruvian textiles, and objects from the southwestern United States and eastern and southern Africa.

12. Much of this information was provided by Russ Kingman, an authority on the life of Jack London. Personal communication to Kathleen Berrin, January 1982.

13. The craze for collecting Indian curios stretched throughout the western United States. Otis Tufton Mason's book, *Aboriginal American Basketry*, may have been a kind of collector's handbook of the time. Personal communications from Lawrence E. Dawson, Research Anthropologist at the Robert H. Lowie Museum of Anthropology, to Kathleen Berrin, January 1982.

14. Further adding to public imagination was Ishi, "the last wild Indian in North America," who had been found north of Oroville in 1911 in an emaciated condition. He was subsequently befriended by Kroeber, who also worked with him in connection with the Anthropology Museum in Parnassus Heights.

15. The Schwabachers' Pacific Heights mansion, for example, had a top floor room designed and decorated solely to house a large and excellent California Indian basket collection.

16. This classic work by one of the foremost anthropologists, Franz Boas (1858-1942), defined fundamental traits of primitive art by drawing on examples from all parts of the world.

17. Templeton Crocker was often accompanied by teams of researchers from natural history museums, especially The American Museum of Natural History in New York.

18. Erle Loran lived in Cézanne's studio in Aix-en-Provence for three years; John Haley studied in Munich where he was strongly influenced by Hans Hoffman. See James B. Byrnes, *The Artist as Collector*, Newport Harbor Art Museum (1975), for further information.

19. Attempts to obtain more precise descriptions of the Wellington Collection were unsuccessful. "Vast" was a word that often occured in interviews, but no one would estimate the number of his holdings. Nor could anyone define major areas or collection strengths. "He collected *everything*" was a frequent comment.

20. The Power House exhibitions were surely pioneering exhibitions of their type, although the de Young Museum and the California Palace of the Legion of Honor also had a surprisingly active program of special exhibitions devoted to objects from Africa, Oceania, and the Americas. Beginning as early as 1928 with an exhibition of Southwest Indian objects, the two museums averaged about ten such exhibitions a decade during the 1940s, 1950s, and 1960s.

21. Earl Stendahl's gallery first opened in the Bachelor Hotel in Los Angeles in 1920.

22. The introduction to the catalogue of the exhibition honoring Dr. Bascom at the Lowie Museum in 1979, *Awon Orisa: Gods of the Yoruba*, noted that in 1957 there had been "fewer than 1,500 catalogue entries for Africa; today there are nearly 14,000."

23. In 1972 the M. H. de Young Memorial Museum and the California Palace of the Legion of Honor merged to form The Fine Arts Museums of San Francisco.

24. Thomas K. Seligman served in the Peace Corps and directed the Africana Museum at Cuttington University College in Liberia.

25. See the 1974-75 publications produced by The Fine Arts Museums of San Francisco and the 1974 publication by Louis A. Allen in the bibliography.

26. Formerly the Museum of Anthropology, renamed and relocated in Kroeber Hall on the Berkeley campus of the University of California since 1959.

BIBLIOGRAPHY

Allen, Louis A. *Australian Aboriginal Art: Arnhem Land.*
Exh. cat. Chicago: Field Museum Press, 1972.

Art of the Northwest Coast. Exh. cat. Robert H. Lowie
Museum of Anthropology, University of California, Berkeley, 1965.

Awon Orisa: Gods of the Yoruba. Exh. cat. Robert H. Lowie
Museum of Anthropology, University of California, Berkeley, 1979.

Bascom, William R. *African Arts: An Exhibition at the Robert
H. Lowie Museum of Anthropology of the Univeristy of California,
Berkeley, April 6-October 22, 1967.* Berkeley: University of
California Printing Department, 1967.

Boas, Franz. *Primitive Art.* First published 1927 by
H. Aschehoug and Co., Oslo, for the Oslo Institute for Comparative
Research in Human Culture; published 1928 by Harvard University.

Byrnes, James B. *The Artist as Collector: Selections from Four
California Collections of the Arts of Africa, Oceania, the
Amerindians and the Santeros of New Mexico.* Exh. cat.
The Newport Harbor Art Museum, 1975.

Dwyer, Jane Powell, and Edward Bridgman Dwyer. *Traditional
Art of Africa, Oceania, and the Americas.* The Fine Arts Museums
of San Francisco, 1973.

_____.*Fire, Earth. . .and Water: Sculpture from the
Land Collection of Mesoamerican Art.* Exh. cat.
The Fine Arts Museums of San Francisco, 1975.

Frye, Melinda Young. *Natives and Settlers: Indian and Yankee
Culture in Early California, The Collections of Charles P. Wilcomb.*
Exh. cat. The Oakland Museum, 1979.

_____."Pioneers in American Museums: Charles P. Wilcomb,"
Museum News, May/June 1977, pp. 55-60,

Ichaporia, Niloufer. "Crazy for Foreign: The Exchange of Goods
and Values on the International Ethnic Arts Market." Ph.
D. dissertation, University of California, Berkeley, 1980.

Kroeber, Theodora. *Ishi in Two Worlds: A Biography of the
Last Wild Indian in North America.* Berkeley: University
of California Press, 1976.

_____.*Kroeber: . . . A Personal Configuration.* Berkeley: University
of California Press, 1970.

Lindsay, George E. "The Wattis Hall of Man." *Pacific Discovery,*
July/August 1976, pp. 1-2. California Academy of Sciences,
San Francisco.

Loran, Erle; Thomas K. Seligman; Jane P. Dwyer; and Edward
B. Dwyer. *African and Ancient Mexican Art: The Loran Collection.*
Exh. cat. The Fine Arts Museums of San Francisco, 1974.

Mason, Otis Tufton. *Aboriginal American Basketry* (or *Indian
Basketry: Studies in a Textile Art Without Machinery*). 2 vols.
New York: Doubleday, Page & Co., 1904.

Menzel, Dorothy. *The Archaeology of Ancient Peru and the
Work of Max Uhle.* Berkeley: Robert H. Lowie Museum of
Anthropology, University of California, 1977.

*The M. H. de Young Memorial Museum, Golden Gate Park, San
Francisco, California.* Published under the auspices of the
Park Commission, 1921.

Miller, Robert Cunningham. "Highlights of a Hundred Years."
Pacific Discovery, March/April 1953. California Academy
of Sciences, San Francisco.

Nicholson, H. B., and Alana Cordy-Collins. *Pre-Columbian Art
from the Land Collection.* Exh. cat. California Academy of Sciences,
San Francisco, 1979.

AFRICA

1 Janus Figure
Dogon, Mali; 20th century
Wood
17-3/8 in. (44 cm.); 3-7/8 in.
(10 cm.); 4-5/16 in. (11 cm.)
The Loran Collection

Many Dogon sculptures are
hermaphroditic, the Dogon
philosophy acknowledging that
male and female features may
coexist, with either dominating at
different times. This piece is
remarkable for the two smaller
figures integrated into the bodies
of the large figures. It has
associations with the ancestral or
mythical world, the ability of
humans to reproduce and the
importance of continuity in
Dogon life; and it may be
connected with commemorative
funerary rites (*dama*) in
which Dogon dance masks figure
so prominently.

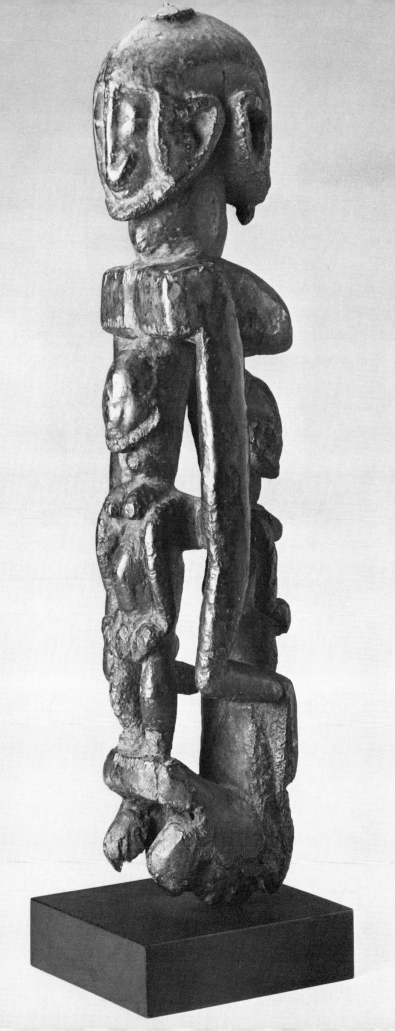

19

2 Mask (*Kanaga*)
Dogon, Mali; 20th century
Wood, paint, fiber, fur,
and animal hide
39 in. (99 cm.); 23-5/8 in.
(60 cm.); 9 in. (23 cm.)
Private collection

Most Dogon masked dances are
performed in conjunction with
funerary rites or with
commemorative celebrations
honoring select individuals. About
seventy-eight different mask types
have been identified among the
Dogon, and stylistic variations in
a given mask occur from village
to village. Certain dance rhythms
are appropriate to select mask
types, and the choice of masks
presented in a single
performance is determined by
the dance master whose
responsibility it is to organize the
event. The Dogon are
accomplished dancers with an
astonishing repertoire of feats
which involve jumping and
twirling the masks in an
impressive manner. *Kanaga*
dancers twist from the waist,
bringing the top of the mask in
contact with the earth. This
particular example is painted
black, white, blue, and red.

3 Chair
Bamana, Mali; 20th century
Wood
29-1/2 in. (75 cm.); 24-1/2 in.
(62.2 cm.)
Collection of James Willis

Chairs are made by many groups
in West Africa; they often serve
as symbols of kingship, power,
and prestige. European-derived
forms of chairs were introduced
as early as 1481 by the
Portuguese. This example is
especially beautiful for its
graceful form and subtle
geometric patterns of stars,
triangles, arcs, rectangles, and
zigzags. The patterns are often
symmetrically placed on both
sides of the chair, conveying
a sense of elegance, repose,
and balance.

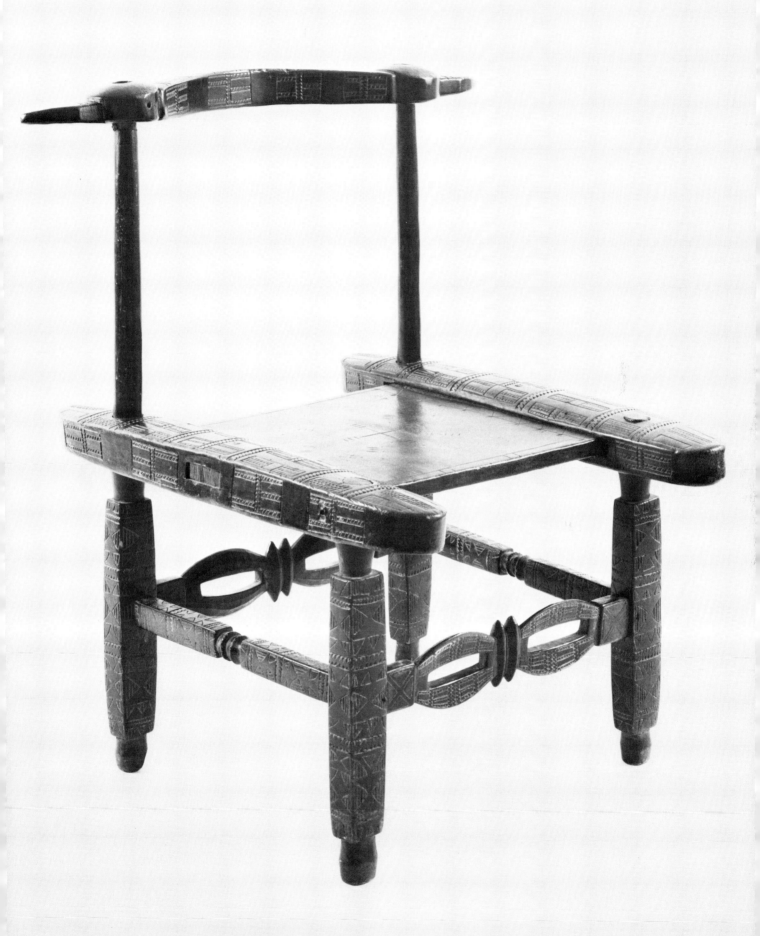

4 Helmet Mask

Northern Senufo or Bamana;
20th century
Wood
7-3/4 in. (19.5 cm.); 9 in.
(23 cm.); 17-3/8 in. (44 cm.)
Ex-coll. Katherine C. White
Private collection

The attribution of this mask is
uncertain but it seems to fall
within the tradition of dark

helmet masks with animal
features used by the Senufo and
Bamana. It probably functioned
within the context of funerary
activities, as its surface is
encrusted with dried blood and
other sacrificial material. Quills
might have projected upward
from the holes in the
central ridge.

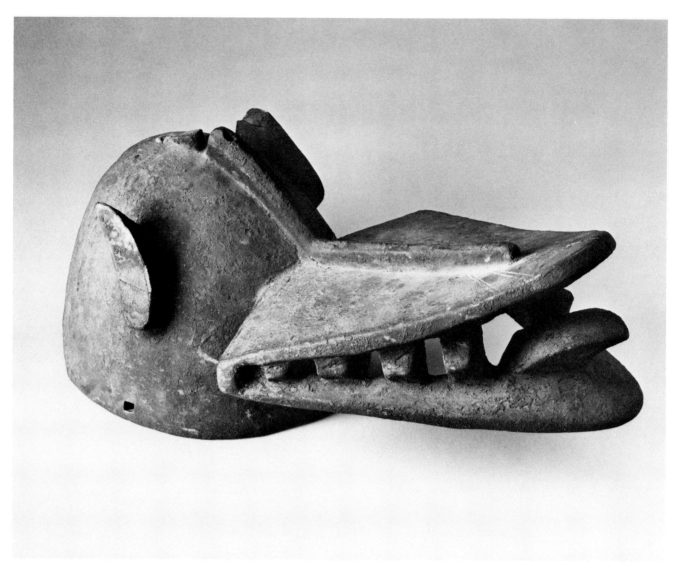

5 Female Figure

Lobi, Upper Volta; 20th century
Wood
37-1/4 in. (94.5 cm.); 7-1/2 in.
(19 cm.); 6-1/8 in. (15.5 cm.)
Private collection

Figures such as this are placed
on household shrines or in
shrines under the control of a
priest-leader. They are believed to
give very specific advice through
the medium of diviners, but their
precise origin and significance
are uncertain. They may
represent protective spirits and be
carved as a remedy for personal
misfortune or illness. The averse
head in this example is an aspect
seen frequently in Lobi sculpture.

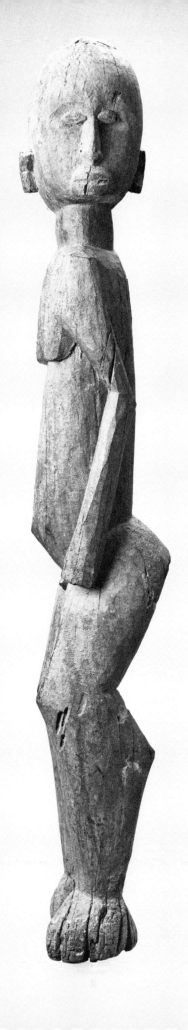

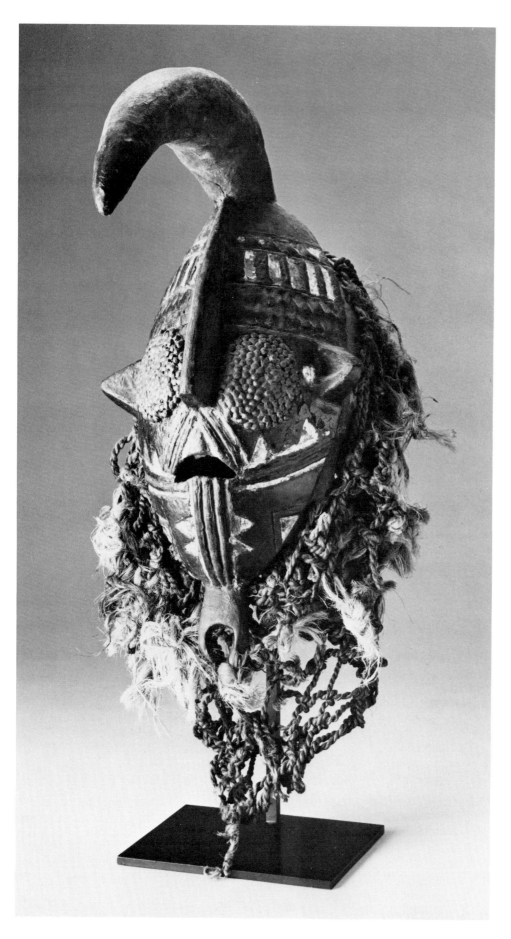

6 Scorpion Mask
Bwa, Upper Volta; 20th century
Wood, paint, fiber, and
abrus seeds
17-1/2 in. (44.5 cm.); 8-1/2 in.
(21.5 cm.); 14 in. (35.5 cm.)
Private collection

Only recently has significant
information on the art of the
Upper Volta become available.
Stylistic categories are still being
developed for mask types, and
the specific uses of masks are
even less well documented. The
active exchange among the Bwa,
Samogho, Gurunsi, and Mossi
has resulted in mutually
influenced mask types and
masking traditions. The colors
black, red, and white are typical
of masks in all these groups, as
are the geometric patterning,
crescent shapes, fiber costumes,
and the use of seeds in the area
of the eyes. This mask was
collected in 1970 in
Bobo-Dioulasso. The prong
beneath the chin connotes the
scorpion, an insect that plays a
role in sorcery in this area.

7 Anthropomorphic Mask *(Molo)*
Bwa, Upper Volta; 20th century
Wood and paint
52 in. (132 cm.); 12 in.
(30.5 cm.); 14 in. (35.5 cm.)
Collection of Mr. and Mrs.
James J. Ludwig

This large and heavy mask has
been documented as a
representation of a divinity. The
geometric decoration (in red,
black, and white), black horns,
and human face with beard are
all typical features. The great
majority of Bwa masks bear
painted geometric decoration, and
while it may be possible that
variations in designs indicate
certain sub-groups, carvers,
localities, or important cosmic or
cultural themes, such assertions
have not been well documented.
The lizard is a symbol found on
many masks from the Sudan.

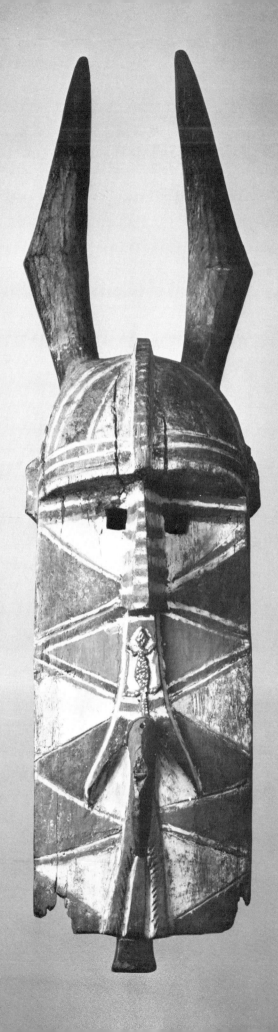

8 Female Figure

Senufo, Ivory Coast; 20th century
Wood
10-1/2 in. (27 cm.); 3 in.
(7.5 cm.); 2 in. (5 cm.)
Collection of Mrs. Sue Niggeman

This unusually beautiful Senufo figural sculpture is of a type commonly represented in collections. Standing figures like this are generally identified as portraying "ancestors," either mythical or remembered from real life. A figure like this may have been used in divination. The Senufo believe their ancestors to be benevolent and protective, and they remember them in communal ceremonies led by the village headman. The scarification marks on the face, breasts, and navel of this figure, as well as the crescent shape on top of the head, are typical features.

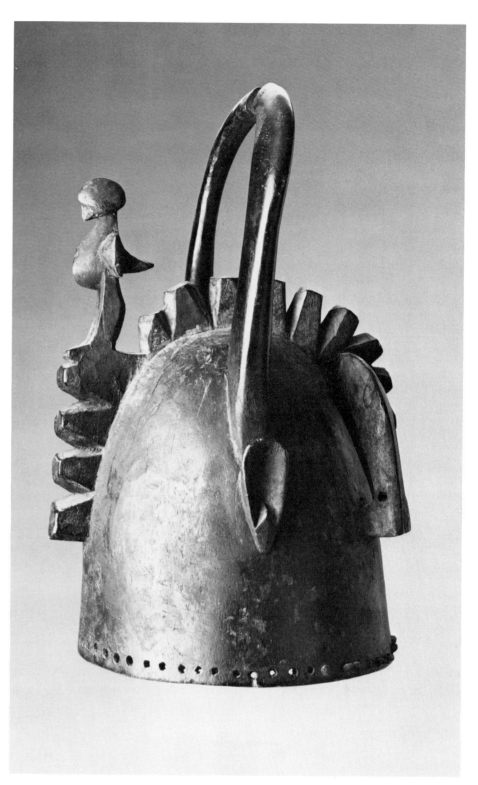

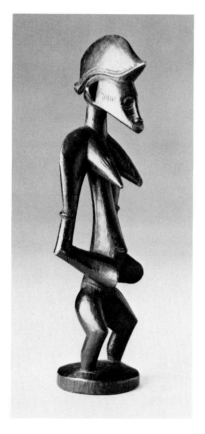

9 Helmet Mask

Senufo, Ivory Coast; 20th century
Wood and leather
12-3/4 in. (32.5 cm.);
9 in. (23 cm.); 8-1/4 in. (21 cm.)
Private collection

Senufo helmet masks are often abstract composites of horned bush animals symbolizing power. Sometimes smaller animals, birds, or human figures are incorporated in the space between the horns, as in this example. The styles, usage, and nomenclature of helmet masks vary among the sub-groups of the Senufo. As the attachment holes around the base of the mask indicate, this example was worn with a body-concealing costume.

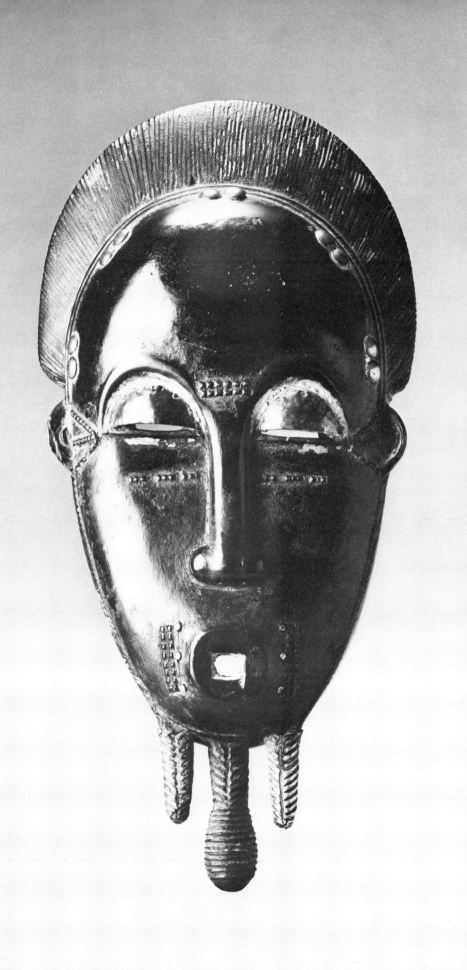

10 Face Mask *(Gba Gba or Gu)*
Wood, metal and paint
12 in. (30.5 cm.); 5-1/2 in.
(14 cm.); 2 in. (5 cm.)
Collection of Mr. and Mrs.
James J. Ludwig
Masks like this are used in
women's dances (dances
associated with women but
performed by men) that feature
the use of masks representing
small animals or human faces.
The purpose of these
performances is to entertain or
teach. They occur on
Baule days of rest or in
conjunction with the funerals of
important women.

11 Mask *(Goli)*
Baule, Ivory Coast; 20th century
Wood and paint
19 in. (48.2 cm.); 11 in. (28 cm.);
3-1/4 in. (8.5 cm.)
Collection of Mr. and Mrs.
Charles Frankel

Goli (also termed *guli*) is the most widespread and beloved of Baule dances, and its performance is a day-long spectacle involving the participation of the whole village. It is a dance of rejoicing performed for the visiting dignitary, to celebrate a good harvest, or during funerals as a means to distract the bereaved. The *goli* mask is worn with a body-concealing costume of raffia and seems to relate to the spirit of the buffalo. The performance was borrowed from the Wan, a group who live to the northwest of the Baule, and was then altered to conform to the Baule world view.

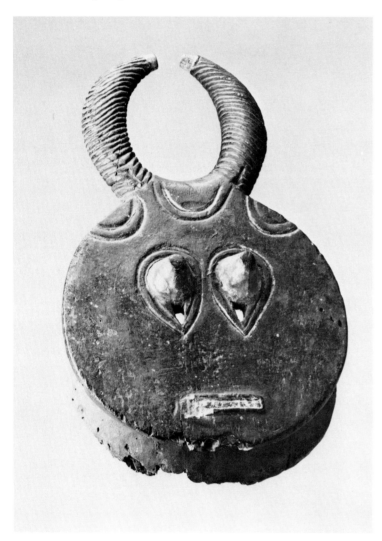

12 Equestrian Figure
Baule, Ivory Coast; 20th century
Wood, leather, and fiber
21-1/2 in. (54.5 cm.); 5-3/4 in. (14.5 cm.); 7-1/8 in. (18 cm.)
The Loran Collection

The Baule do not carve ancestor figures; they carve figures relating to the spirit world—either spirit spouses *(blolo bla)* or nature spirits *(asie usu)*, both of which serve to help an individual avoid trouble or harassment by a vengeful spirit. If this figure is a spirit spouse, it represents a particular Baule woman's husband in the spirit world before she was born into this one and may have been placed on a personal shrine in order to avert his jealousy. If it is a nature spirit, it would have been used similarly, the details of scarification, age, and posture having been dictated by the threatening spirit.

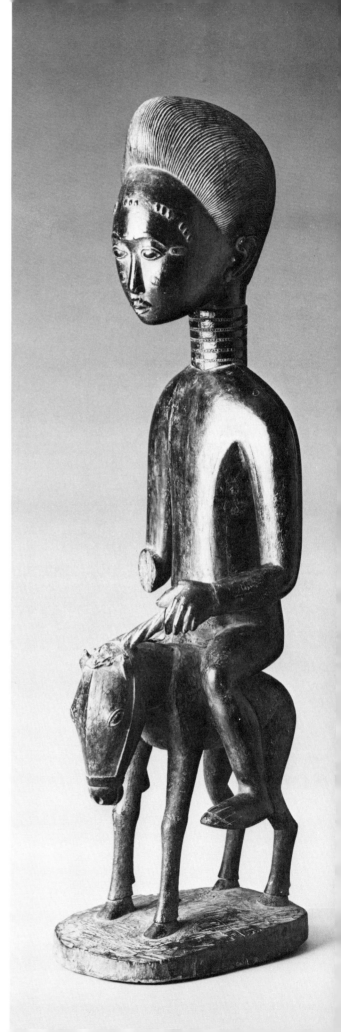

13 Face Mask

Guro, Ivory Coast; 20th century
Wood
11 in. (28 cm.); 6 in. (15 cm.);
5-3/8 in. (13.5 cm.)
Collection of Dwight Strong

The features of Guro masks often resemble those of the Baule, but the origin or interrelationship of stylistic influences between the two groups is unclear. This is an especially elegant example of a type of mask that has reportedly been used in societies called *gu* or *gye*.

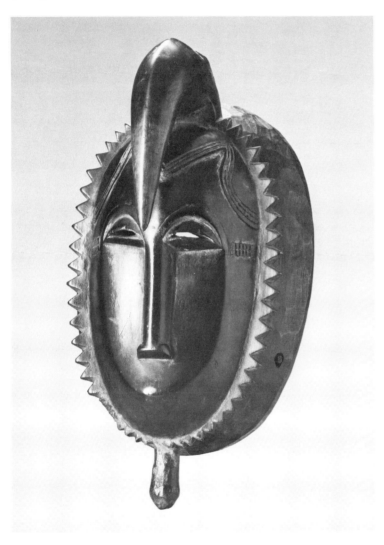

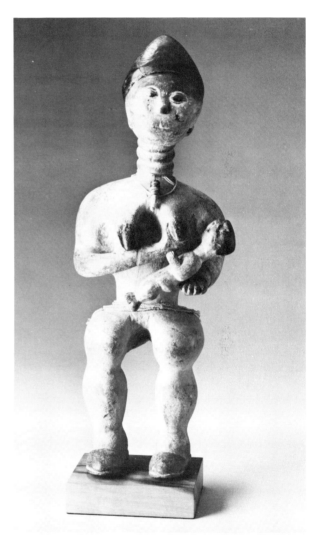

14 Mother and Child

Akan, Ivory Coast; 20th century
Wood, paint, and beads
20-1/2 in. (52 cm.);
7-1/2 in. (19 cm.);
6-1/2 in. (16.5 cm.)
Collection of Mr. and Mrs. James J. Ludwig

The theme of motherhood is clearly central for the Akan people, and mother-and-child images outnumber all other types of carvings with the exception of *akua'ba* (fertility dolls used by pregnant women). Figures such as this example seem to have been placed on shrines. They relate to fertility, nurturing, and the importance of family, lineage, and state. This figure is painted black and white, wears backless Muslim-style shoes, and bears scarification marks on face, chest, shoulders, and back.

29

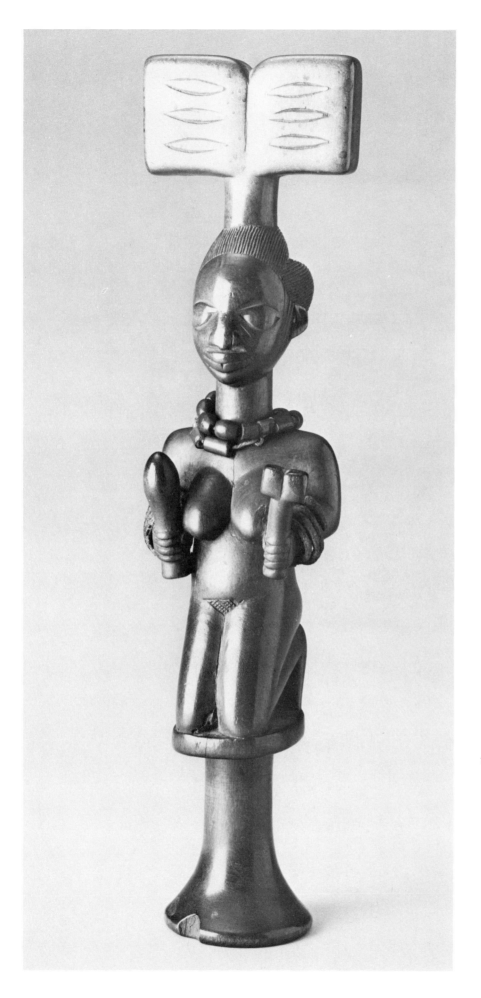

15 Dance Wand or Staff
(Oshe Shango)
Yoruba, Nigeria; 20th century
Wood, beads, and fiber
13 in. (33 cm.); 3-1/8 in.
(8 cm.); 2-3/8 in. (6 cm.)
Private collection

Shango is the Yoruba god of
thunder and lightning; dance
wands or staffs such as this are
symbols of his power. A Shango
priest or priestess carries the
oshe shango not simply as a sign
of devotion but also as a
reminder of Shango's power to
bring destruction to those who
do not worship him. *Oshe
shango* are usually carved from
African satinwood *(ayan)*, a tree
that is sacred to many Yoruba
deities. This unusually well-used
and beautifully patinated example
is said to have belonged to a
Yoruba priestess.

16 Mother and Child
Yoruba, Nigeria; 20th century
Wood and paint
27-1/8 in. (69 cm.); 4-3/4 in.
(12 cm.); 5-5/16 in. (13.5 cm.)
The Loran Collection

The theme of motherhood has
assumed great cultural
importance for the Yoruba. The
specific use of this figure is
unknown, but it probably comes
from an eastern region. The
kneeling attitude, seen frequently
in the sculpture of the Yoruba, is
a gesture of respect suggesting a
relationship to a higher force.

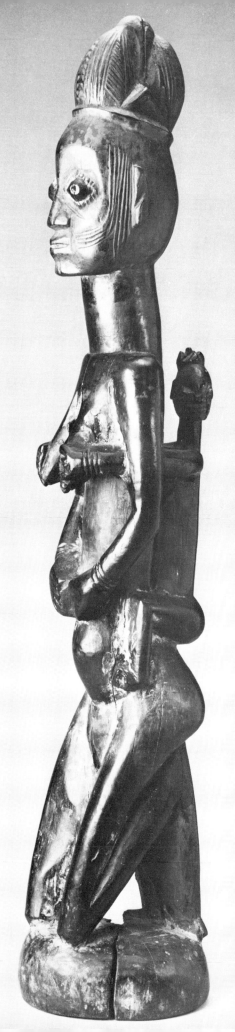

17 Divination Bowl (*Agere Ifa*),
probably by Ojerinde Adugbologe
(1850-?)
Yoruba, Abeokuta, Nigeria;
late 19th century
Wood and paint
10-3/4 in. (27 cm.); 10 in.
(25.4 cm.)
Private collection

This elaborate bowl was carved
from a single piece of wood. Its
function is the same as that of
the following entry. Represented
at center is a chief on horseback
who is surrounded by his two
wives and three attendants. To
his immediate right, one wife
holds a lidded pot. His second
wife, who follows behind the
first, carries on her back a baby
who looks out to the side. The
attendant to the chief's immediate
left carries an axe or adze, an
attribute of power, over his left
shoulder. The second attendant
follows playing a talking drum; a
third holds a musket. The bowl is
painted in red, white, blue, and black.

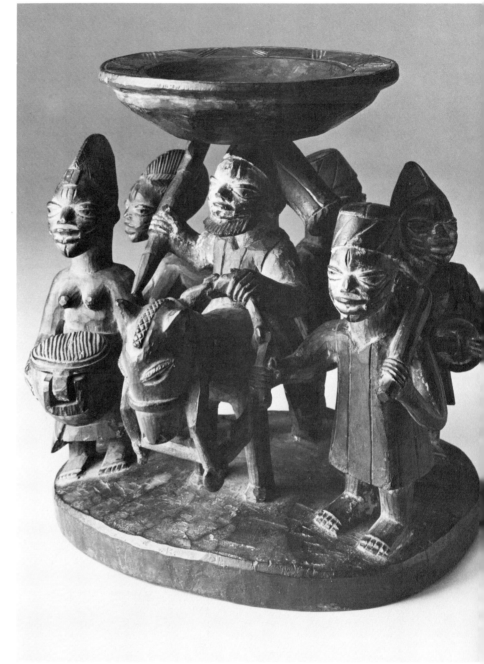

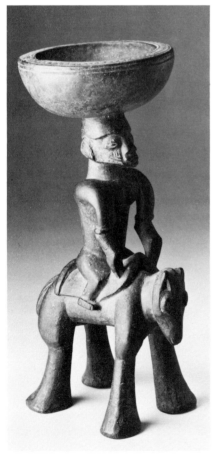

18 Divination Bowl (*Agere Ifa*)
Yoruba, possibly from
Ogbomosho, Nigeria; 20th century
Wood
11-1/4 in. (28.5 cm.); 5 in.
(12.5 cm.); 6-1/8 in. (15.5 cm.)
Private collection

Ifa is a system of divination
based on certainty and order; the
Ifa cult functions to heal the sick
and foretell the future. Ifa
diviners use sixteen palm nuts,
which are kept in special
elevated bowls such as this. They
throw the palm nuts into a
divination tray on which powder
is spread. The resulting pattern is
then interpreted according to a
complex system the diviner has
memorized.

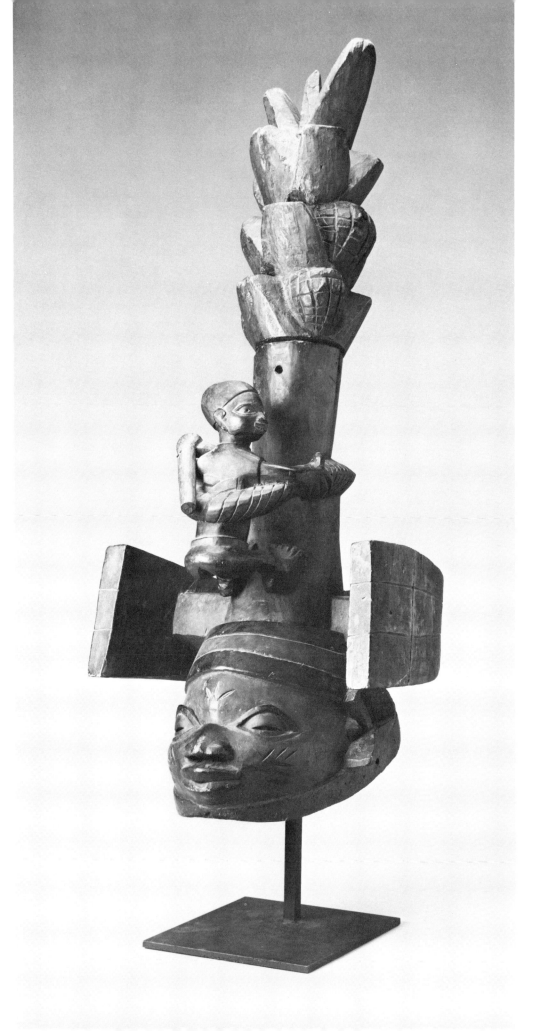

19 Mask *(Gelede)*
Yoruba, Nigeria; 20th century
Wood and paint
31-1/4 in. (79.5 cm.); 12 in.
(30.5 cm.); 12 in. (30.5 cm.)
Private collection

In the southwestern Yoruba area,
the cult of Gelede is very
prominent. Gelede is a deity
believed to have been a witch
when she lived on earth. She is
honored and appeased through
sacrifices, prayers, and masked
dances performed by men in
pairs. The mask shown here is
made in two parts, the smaller
element forming the top of a
palm tree. The figure climbing
the palm carries an axe over his
shoulder. The mask is painted
red and black.

20 Twin Figures *(Ere Ibeji)*
Yoruba, Ila area, Nigeria;
20th century
Wood, paint, beads, and fiber
11-1/2 in. (29.2 cm.); 3-1/4 in.
(8 cm.); 3 in. (7.5 cm.)
Collection of Mr. and Mrs.
Charles Frankel

Among the Yoruba, twins are
thought to bring good luck; and
while the occurrence of fraternal
twins is frequent, the rate of
infant mortality is also high. It is
thought that twins are linked by
inseparable souls, and if one or
both twins die, the mother
commissions a sculptor to make
a small figure or figures to
contain the spirit of the deceased.
The *ibeji* are cared for so that
the power of the dead will work
for the good of the family. This
male and female pair is carved
in the style of Dagikonle of
Igbomole.

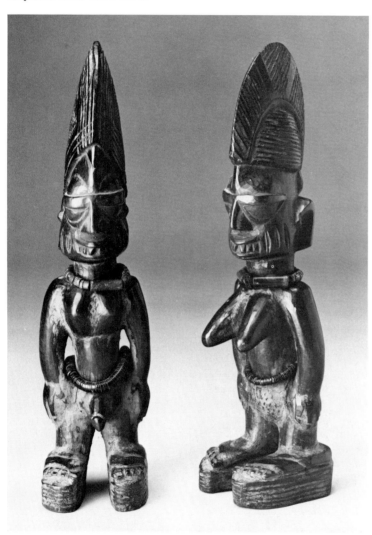

21 Carved Post
Yoruba, possibly near Efonalaye,
Nigeria; 20th century
Wood and traces of paint
59-1/2 in. (151 cm.); 7 in.
(18 cm.); 8-1/2 in. (21.5 cm.)
Collection of Dwight Strong

Impressively carved posts or poles
such as this lined the courtyard
verandas of Yoruba palaces, deity
shrines, or homes of important
people. The purpose of these
posts was both structural and
symbolic, their number and
detail serving to enhance the
power of royalty or the
prominence of the owner.
Common themes on such posts,
shown on the example illustrated
here, are the equestrian, warrior,
and mother and child.

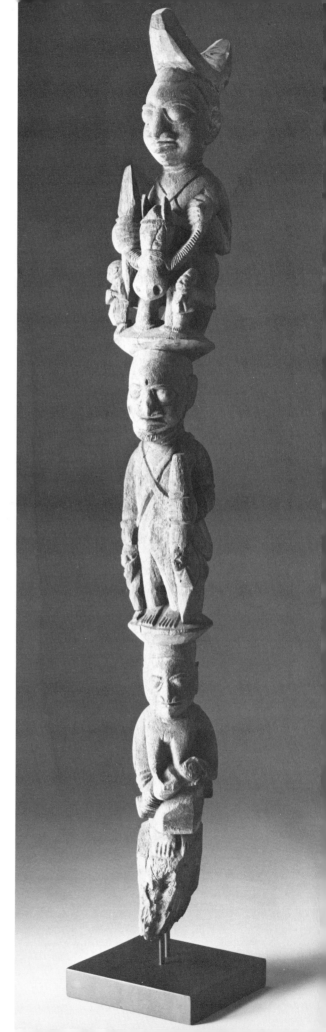

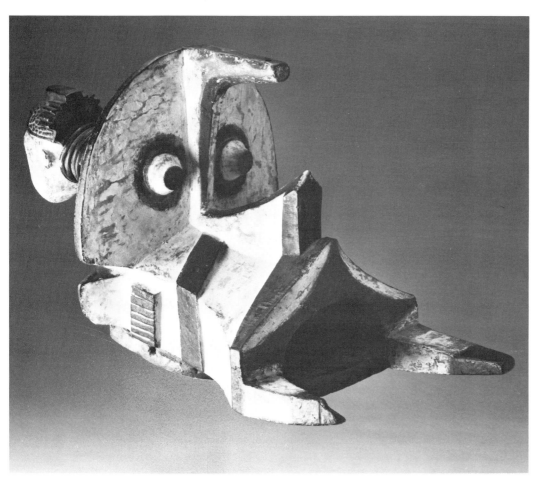

22 Elephant Mask

Ibo, Izzi Village, Nigeria;
20th century
Wood, paint, and metal
14 in. (35.5 cm.); 12 in.
(30.5 cm.); 24 in. (61 cm.)
Private collection

A number of tribes, all linguistically related, inhabit the Cross River area on the border between Nigeria and Cameroon. This mask combines elephant and human forms in one striking conception. The idea of multi-faced masks suggests increased power and vision. Two-part forms may metaphorically suggest an important cultural duality such as humans versus the forces of nature. This mask was probably used in a masquerade performance associated with a significant life event and would have been worn horizontally on top of the head with the wearer seeing through the mouth.

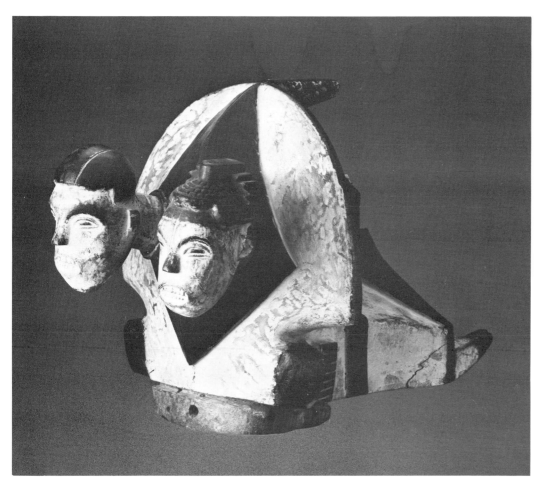

23 Face Mask

Southern Ibo, southeastern Nigeria; 20th century
Wood and paint
9 in. (23 cm.); 5-3/4 in. (14.8 cm.); 3-1/2 in. (9 cm.)
Private collection

Wood masks are a major art form of the Ibo, who create hundreds of different types. Face masks with costumes are worn by male secret society members in public masquerades that often focus on social criticism or satire of particular individuals for purposes of social control. This white-faced mask with black details may have been used for the role of a beautiful girl in a play called *Okorosia*.

24 Head Crest

Ibo or Idoma, Cross River area, Nigeria; 20th century
Wood and paint
14 in. (35.5 cm.); 7 in. (17.8 cm.); 7 in. (17.8 cm.)
Collection of Mr. and Mrs. James J. Ludwig

The stylistic features of this head crest—so called because it is worn on top of the dancer's head—are typically Idoma, particularly the use of heavy black detailing against a white face surface. The headcrest form is perhaps better known among the Ibo, but a number of Cross River tribes use it in masquerade performances.

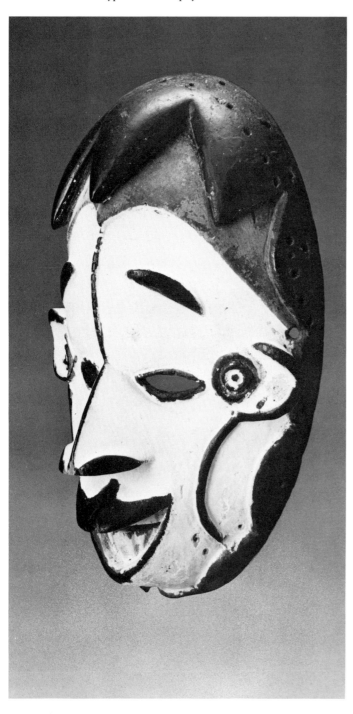

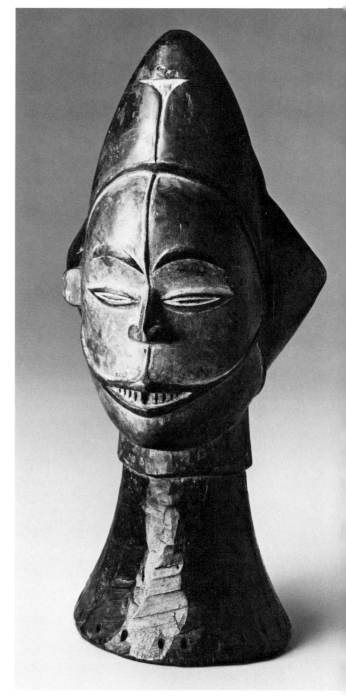

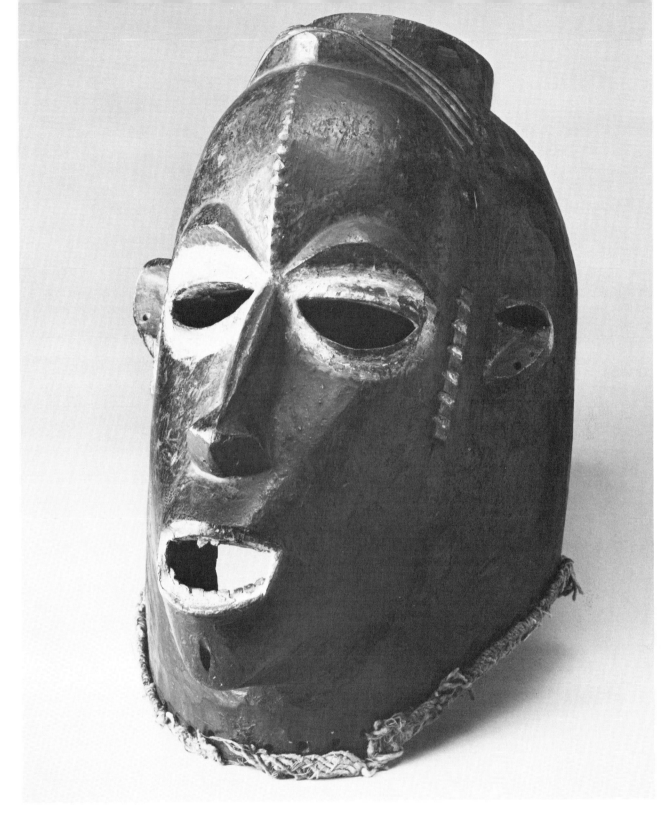

25 Helmet Mask

Possibly Ibibio or Ekoi, Cross
River area, Nigeria; 20th century
Wood, paint, and fiber fringe
17 in. (43.1 cm.); 10 in. (25 cm.);
18 in. (46 cm.)
Collection of Dr. and Mrs.
Ralph Spiegl

Nigeria's Cross River area is a
dense tropical forest populated by
a number of different tribes with
intermingled art styles. This
black helmet mask may be Ibibio
or Ekoi, perhaps even Ibo, and
may have been used in
masquerade performances given
for a variety of reasons by secret
societies. The mask is an
unusually powerful one, with
white paint applied around the
eyes and mouth. At the
immediate top back of the mask
is a small face (approx.
3-1/2 in. x 4-1/2 in.), also with
white paint in the eyes and
mouth, perhaps symbolizing the
all-seeing spirit world. Numerous
perforations on top of the head
and an unpainted depression
carved out of the top suggest that
it once bore an attachment.

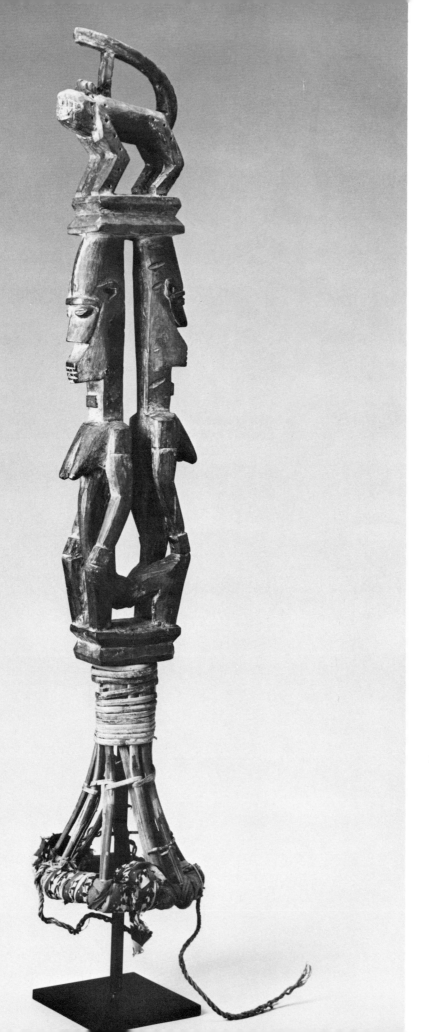

26 Head Crest

Isoko or Kwale Ibo, Nigeria;
20th century
Wood, paint, cloth, and fiber
33-7/8 in. (86 cm.); 6-1/4 in.
(15.5 cm.)
The Loran Collection

Worn on top of a dancer's head
with a body-concealing costume
descending from it this tall and
impressive head crest features
two nude females back to back,
crowned by a small animal
resembling a monkey. The
symbolism or precise use of this
head crest is unknown, but the
theme of duality is an important
one expressed in the art of many
groups throughout the Niger
River Delta. The style of this
piece recalls the tradition of
whitened ancestor sculptures
among the neighboring Urhobo.

27 Protective Figure

Chamba, northeast Nigeria;
20th century
Wood and paint
20-1/2 in. (52 cm.); 8-1/4 in.
(21 cm.); 5-1/2 in. (14 cm.)
The Loran Collection

This piece represents a rare type
made by the Chamba; similar
figures are also made by the
nearby Waja and Kutini of
Cameroon. Single and double
figures such as this assumed a
protective function when placed
on the ground either inside the
dwelling or in front of the
outside door.

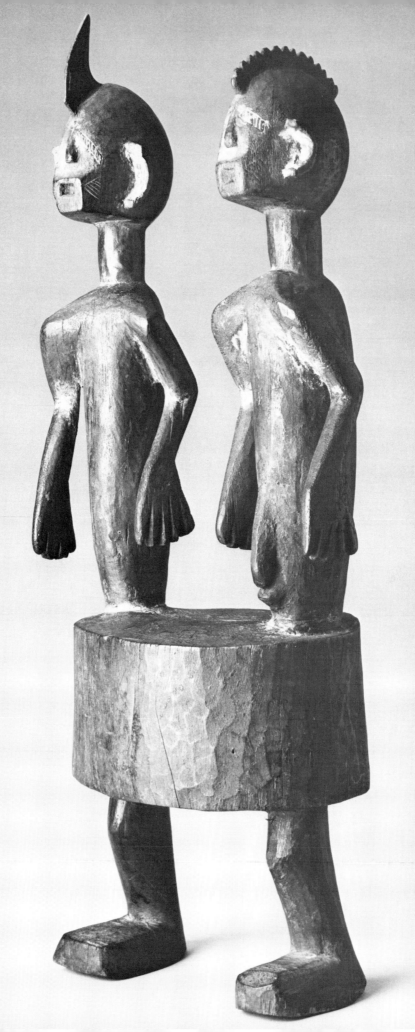

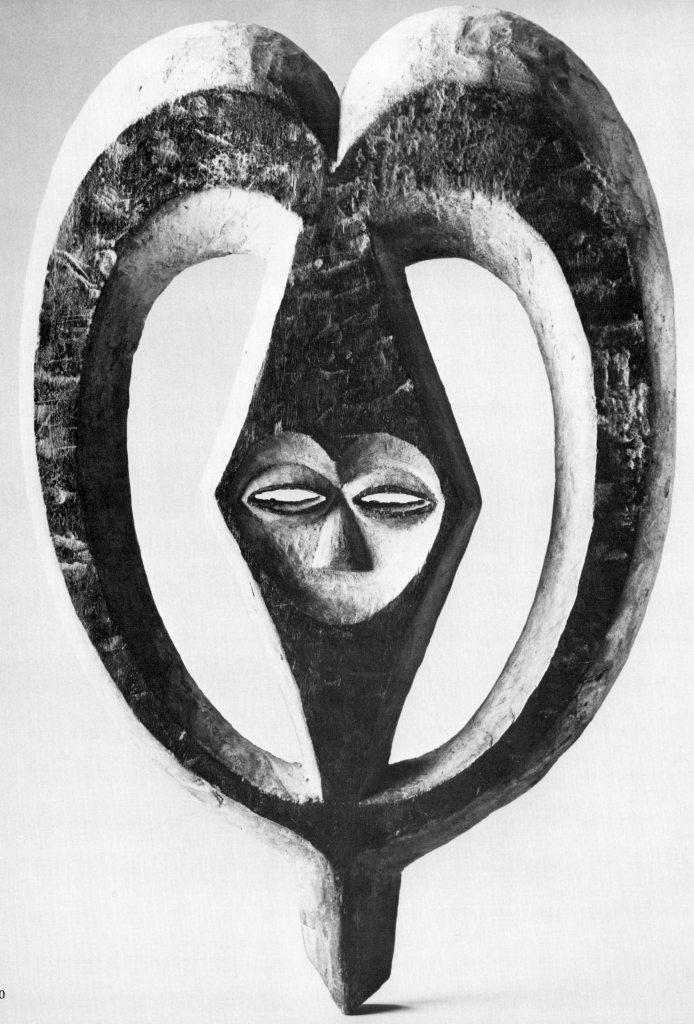

28 Mask

Kwele, Gabon; late 19th century
Wood and paint
16-1/2 in. (42 cm.); 11-1/4 in.
(28.5 cm.); 1-1/2 in. (3.6 cm.)
Private collection

Masks like this were in use at
the turn of the century but fell
into disuse after the 1920s. They
may have been used in rituals
that validated the status of Kwele
clans, but they have also been
reported as hangings for the end
walls of ceremonial houses.

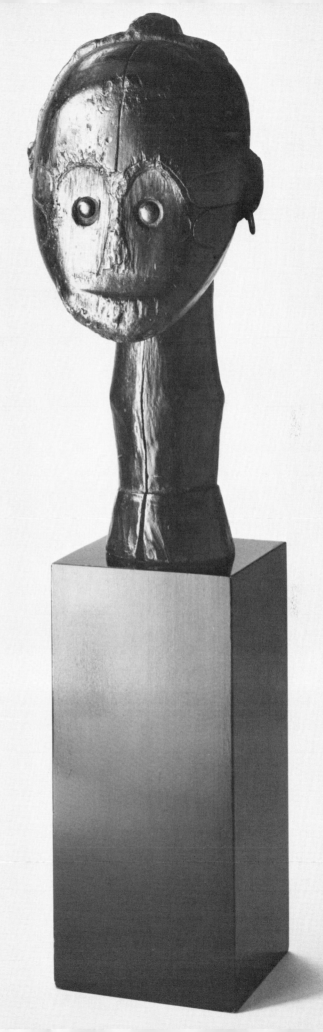

29 Reliquary Head *(Bieri)*

Fang, Gabon; late 19th century
Wood, European carpet tacks,
and metal ring
Without stand: 10 in. (25.5 cm.);
5 in. (12.7 cm.); 4 in. (10 cm.)
Ex-coll. Helena Rubenstein
Private collection

Wooden reliquary heads like this
served as guardian figures for the
skulls and precious bones of
important ancestors, to drive
away intruders, particularly the
uninitiated. Such objects were
given offerings of food and
cleansings of palm tree oil to
restore their powers and abilities
to intercede with the ancestors on
behalf of the living. The nose
and mouth area on this example
have been rubbed away through
ritual usage. It is mounted on an
Inagaki stand.

30 Comb

Fang, Gabon; 20th century
Wood
16-1/2 in. (42.5 cm.); 3 in.
(7.5 cm.); 1-1/8 in. (3 cm.)
MEPA Collection

This six-pronged comb features
the head, upper torso, and
delineated navel of a female who
appears to be holding an object
on her head. Despite the fact that
combs are generally utilitarian
and non-ritual objects, the one
shown here may reflect the
principle of balanced opposition,
spatially rendered, which has
been described as a prominent
feature of Fang ritual sculpture.
The Fang consider the head and
stomach to be opposing entities,
their juxtaposition creating
vitality.

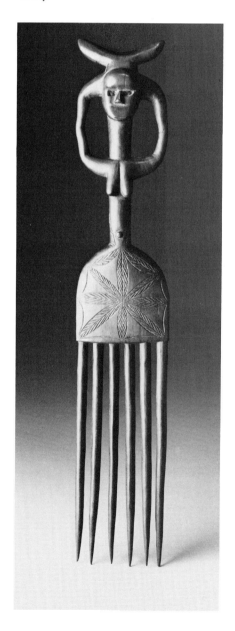

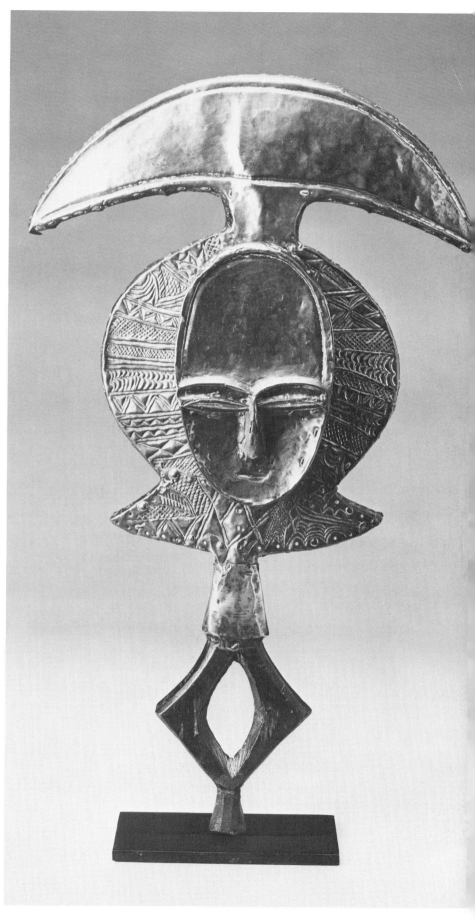

31 Reliquary Figure *(Mbulu Ngulu)*
Kota, Gabon; 20th century
Wood, brass, and copper
26-1/2 in. (67.2 cm.); 16 in.
(40.8 cm.); 3 in. (7.5 cm.)
Collection of Mr. and Mrs.
James J. Ludwig

Reliquary figures such as this
served as guardian images; they
were placed on top of baskets or
boxes containing the bones of
revered ancestors in order to give
protection against witchcraft. The
Kota and nearby groups use
reliquary figures that function
similarly to those of
the Fang, although the style
is completely different from
Fang *bieri*.

32 Shrine or Guardian Figure
Mitsogho, central Gabon;
20th century
Wood, paint, and metal
54 in. (137 cm.); 9-5/8 in.
(24.5 cm.); 9-3/8 in. (24 cm.)
Ex-coll. Durand Reville
Private collection

The Beete cult, which requires
the propitiation of cult ancestors
in order to obtain their aid and
protection, is central to social
and religious life among the
Mitsogho. Beete temples require a
number of human, animal, and
geometric sculptures. Their
configurations are especially
meaningful and correspond to the
requirements of Mitsogho
mythology. It is possible that this
female figure stood in the center
of a Beete shrine. Her body is
covered with the white paint that
signifies the spirit world in this
part of Africa.

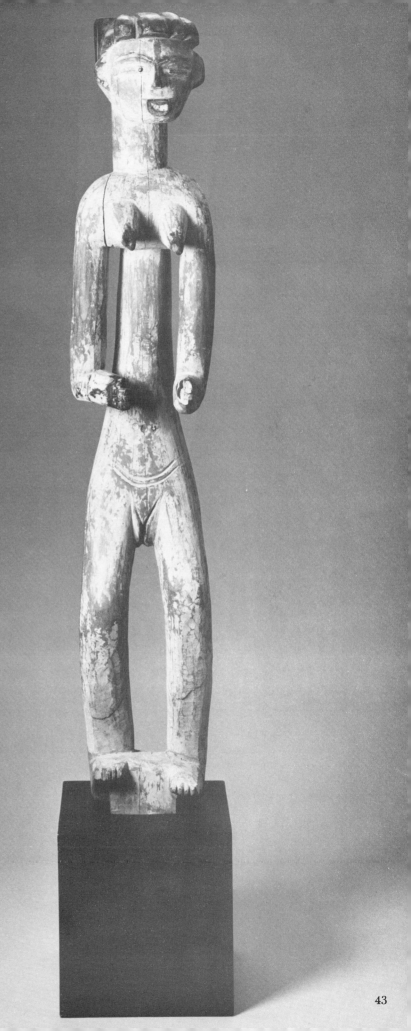

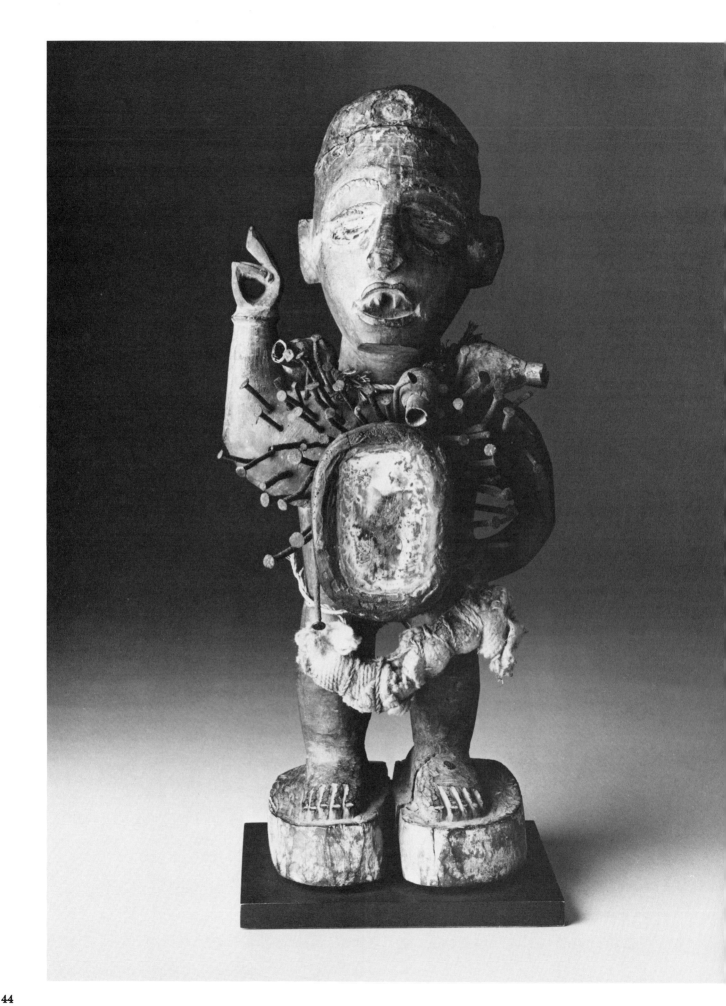

33 Nail Fetish

Kongo, Mayombe region, Zaire;
20th century
Wood, mirror, clay, and fiber
13 in. (33 cm.); 5-1/2 in.
(14 cm.); 5-1/8 in. (13 cm.)
MEPA Collection

Nail fetishes are powerful objects whose purpose is to resist evil and destruction. They are generally kept by sorcerers and activated by driving a nail into the image, which will then redirect illness or other misfortunes upon an enemy. Like many fetishes, this example has a mirror-covered stomach cavity and mirror-covered eyes to reflect or deflect misfortune and destroy its source. Offertory materials and substances are also applied to fetishes, and hanging ornaments, such as knotted cloth, shells, and beads, were mnemonic devices to help the spirit remember the complaint of the individual.

34 Mirror Fetish

Vili, 20th century
Wood, mirror, and fiber
8 in. (20.25 cm.); 2-3/4 in.
(7 cm.); 2-3/4 in. (7 cm.)
Private collection

Mirror fetishes are used for divination and foretelling the future. Only individuals with specialized knowledge are able to make such interpretations by reading the mirror, the reflective quality of which seems to signify the possibility of seeing beyond visible objects and possessing mystic vision. The stomach cavity behind the mirror is generally filled with magical substances that are conceived as a source of the figure's power. Vili style is more detailed and realistic than that of other groups in this area.

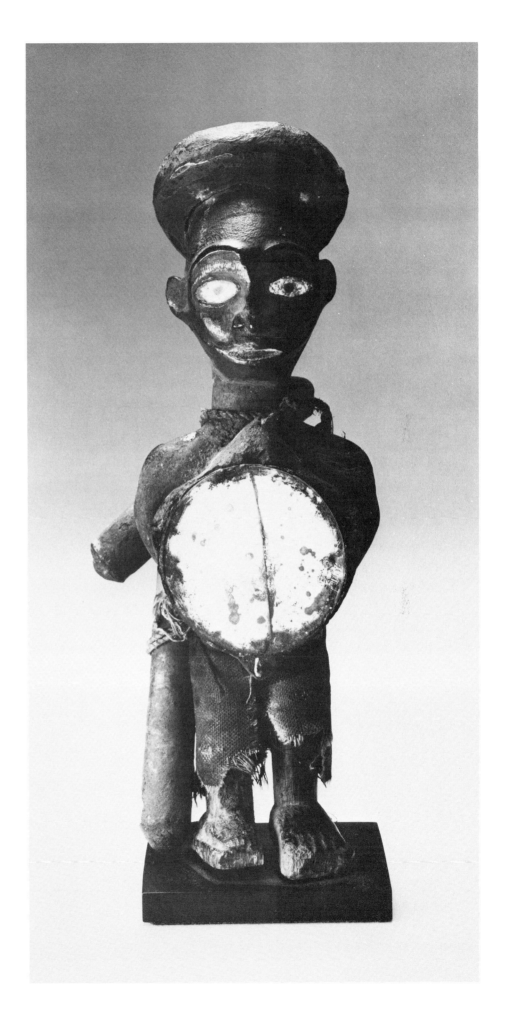

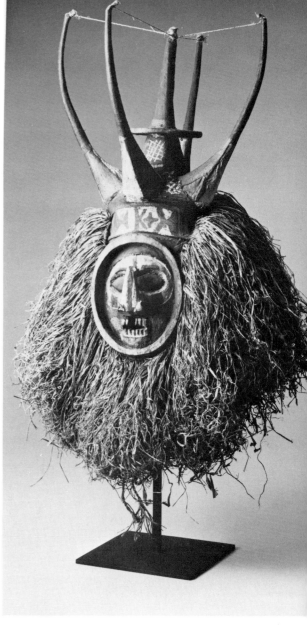

35 Helmet Mask (Below)

Kwese, Zaire; 20th century
Wood, raffia, paint, cotton cloth,
other fiber, and encrustation
25 in. (63 cm.); 19 in. (48 cm.);
15 in. (38 cm.)
Collection of Dr. and Mrs.
Ralph Spiegl

Closely related to the Yaka and
the Suku, the Kwese are the
western neighbors of the Pende.
The art of the Kwese is not well
documented but seems to have a
more naturalistic style, as this
peaceful white-faced mask with a
red crescent shape surmounting
the forehead suggests. The black
headdress is composed of four
fiber bundles and two extensions
which are stiffly encrusted. The
blue and white cotton circular
attachment to the left of the
chin is a beautiful foil to the
other colors.

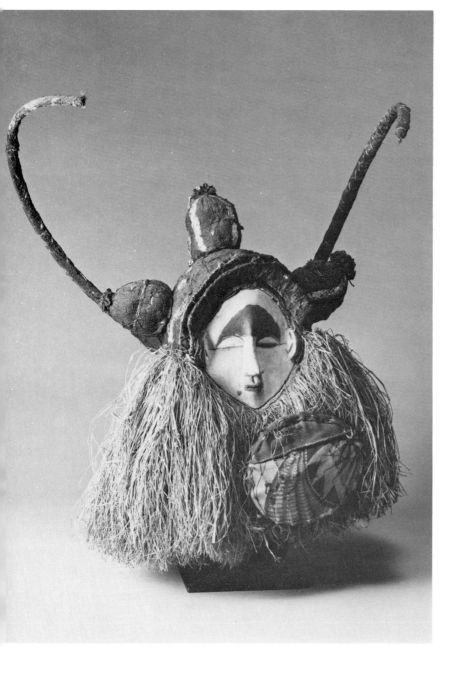

36 Mask (Above)

Yaka, Zaire; 20th century
Wood, fiber, paint, and cloth
25-1/4 in. (64 cm.); 18-1/2 in.
(47 cm.); 15 in. (38 cm.)
Private collection

Masks like this one are used by
the Yaka in initiation ceremonies
called *nkanda* and are worn by
adolescent boys in public
"coming out" ceremonies that
celebrate the end of the initiation
ordeal. The Yaka have a
remarkable sense of creativity,
and many of these masks bear
elaborate imagery, figural and
non-figural, on top of the
headdress. This particular mask
is painted in red, white, blue,
and black and bears the
characteristic upturned nose
which hints at the phallic
imagery often made quite explicit
in dance contexts.

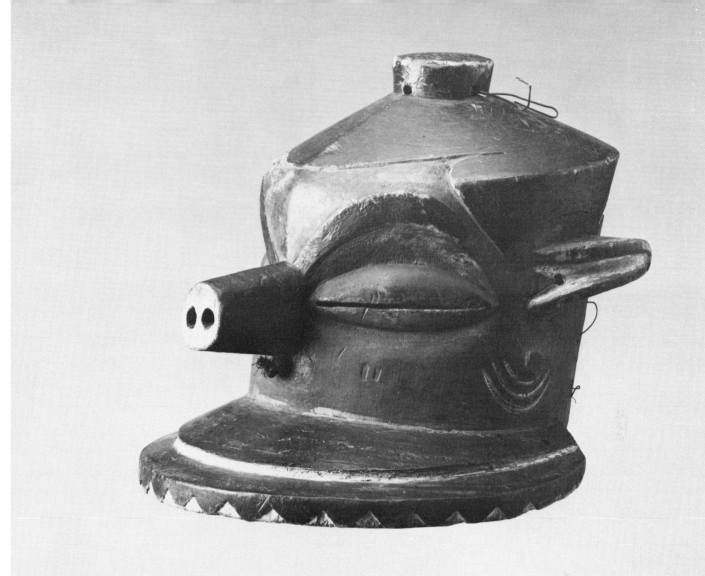

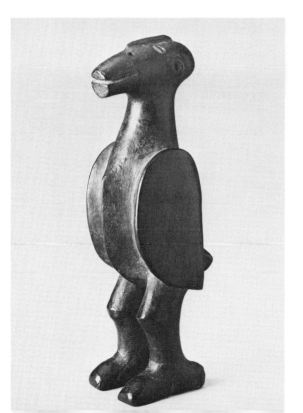

37 Bird Figure

Holo, Angola and Zaire;
20th century
Wood with traces of red paint
9 in. (23 cm.); 2-3/8 in.
(6 cm.); 3-1/8 in. (8 cm.)
The Loran Collection

The Holo, a small group on the
upper Kwango River, produce a
variety of carvings including
statuettes, fetishes, healing drums,
votive axes, and circumcision
masks. Protective bird figures are
common, sometimes placed on
the walls of houses to give
protection from lightning. The
Holo seem to excel in small-scale
sculptures, of which this is a
particularly refined and
abstracted example. Similar
sculptures of birds have been
reported among the Chokwe.

38 Mask (*Kiphoko*)

Pende, Zaire; 20th century
Wood, paint, and fiber
10-1/4 in. (26 cm.); 11 in.
(28 cm.); 13 in. (33 cm.)
Private collection

Eastern Pende groups use the
kiphoko (also *giphogo*) mask in
healing ceremonies, but such
masks are also frequently used in
important rites connected with
the power of the chief and the
ancestor cult, most especially in
circumcision rites (*mbuya*) which
are plays symbolizing the death
and regeneration of the initiates.
In *mbuya* plays as many as
twenty masks may appear,
representing tribal heroes
or other village personages.
This mask is dark, painted in
red, black, and white geometric
patterns.

39 Mask *(Kifwebe)*

Songye, Zaire; 20th century
Wood and paint
12 in. (30.5 cm.); 6-1/4 in.
(16 cm.); 7-1/8 in. (18 cm.)
Private collection

Kifwebe is a type of mask
believed to have extraordinary
powers. Only those who had
passed through several initiations
were allowed to wear the mask,
and only certain persons could
care for it. In use, the mask
would be activated by rubbing
ritual substances on its surface.
The wearer was thereby
transformed into something that
was neither human nor spirit.
This example was collected in
the vicinity of Kamina, region
of Katanga.

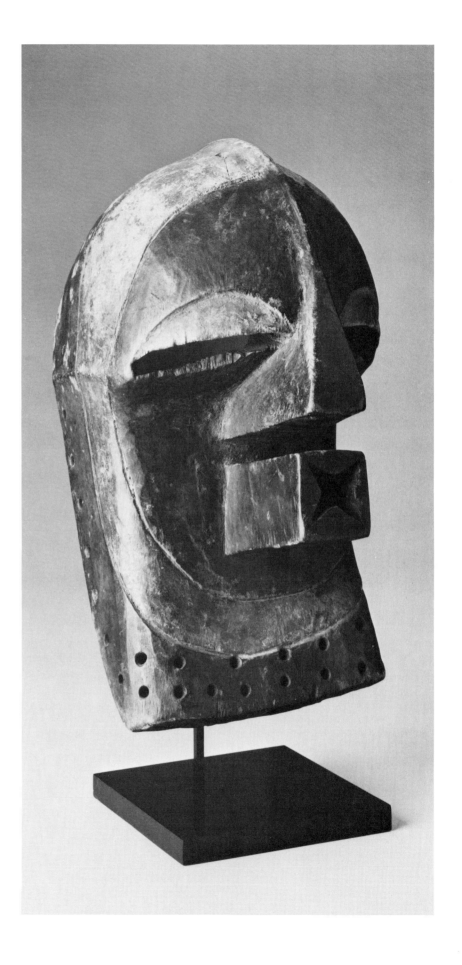

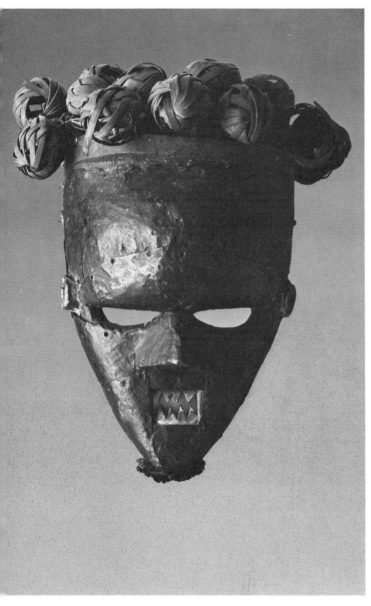

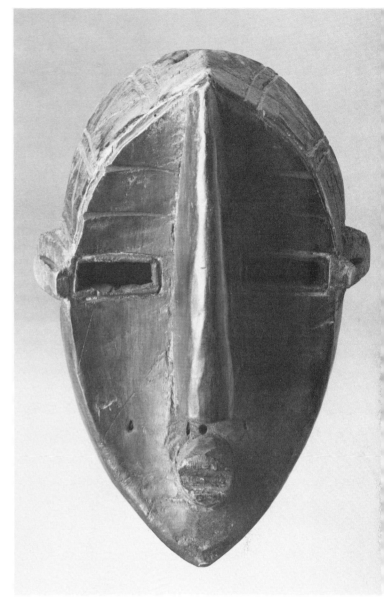

40 Face Mask
 Salampasu, Zaire; 20th century
Wood, copper, and fiber
12-5/8 in. (32 cm.); 11 in.
(28 cm.); 10-1/4 in. (26 cm.)
Private collection

This mask is composed of copper
plates hammered over a wood
base, with plaited fiber balls on
the headdress. Stylistically,
Salampasu masks are
characterized by a jutting
forehead and the use of white
contrasts, here seen in the teeth
and ears, against a darkly
colored area. Such masks are
used for a variety of purposes, all
having to do with male power.
They are used in men's society
rites to gain political dominance
or success in warfare, as well as
in initiation rites or rituals in
which it is necessary to evoke the
spirit world.

41 Face Mask
 Lwalwa, southern Zaire or
Angola; 20th century
Wood and paint
11 in. (28 cm.); 7 in. (17.6 cm.);
6-1/2 in. (16.5 cm.)
Collection of Dr. and Mrs.
Ralph Spiegl

This mask was possibly used for
initiation or circumcision ritual in
a graded or secret society. The
mask was worn by means of a
cord threaded through the hole
between its lips and nose and
held between the teeth of the
dancer. Among the Lwalwa, the
mask carvers are usually the
chiefs, who also organize the
dances in which the masks are
used. Often such masks appear
in pairs.

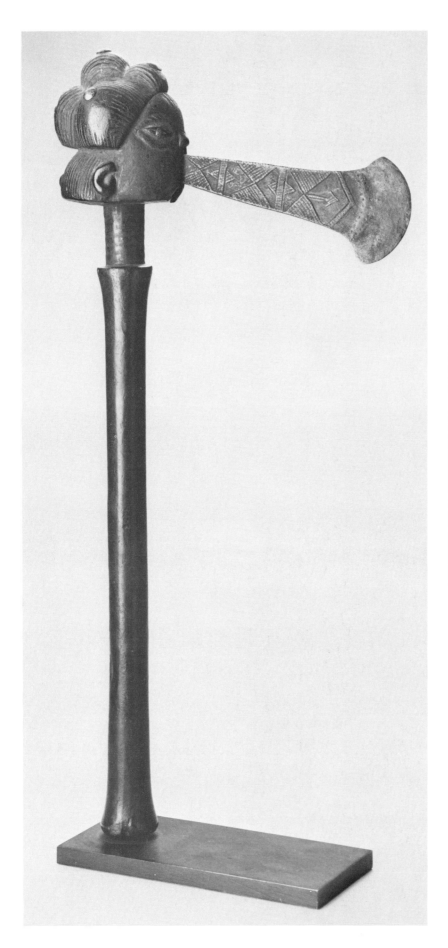

42 Ceremonial Axe
Luba, Zaire; 20th century
Wood and metal
18-1/8 in. (46 cm.); 2-3/4 in.
(7 cm.); 8-1/2 in. (21.5 cm.)
Private collection

Axes are of great ceremonial or symbolic importance in many parts of central Zaire and are carried on the shoulders of important personages as power emblems or attributes of kingship. These axes are often symbolically embellished and beautifully carved. This example is distinguised by the incised blade and the carefully worked coiffure.

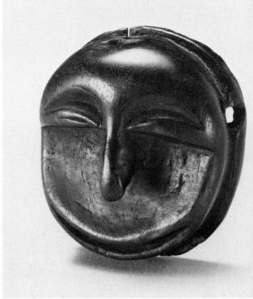

43 Monkey Mask
Hemba, Zaire; 20th century
Wood
2-7/8 in. (7.5 cm.); 2-1/2 in.
(6.5 cm.); 1-1/4 in. (3.25 cm.)
Private collection

Small masks resembling monkeys or chimpanzees are kept inside Hemba houses for protection and to promote fertility. They are not worn as face masks. Though they display an interesting range of forms and expressions, they are generally portrayed with what we would interpret as "pleasant" faces. Monkey masks are not common to other tribes in Zaire but are found frequently among the Hemba, who call them "monkey faces" rather than masks. One source documents the use of these as dance belt masks; the well-worn holes on this example would corroborate that specific usage.

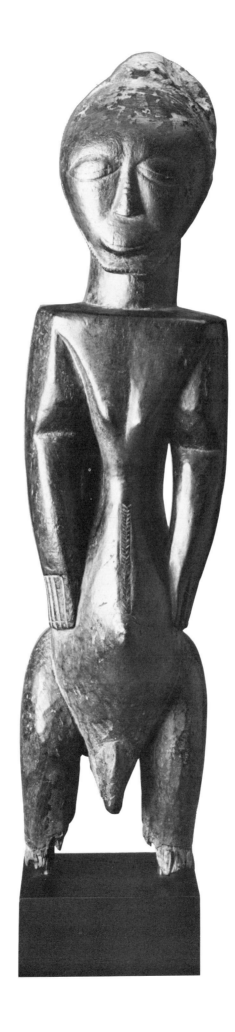

44 Male Figure

Hemba, Zaire; 20th century
Wood
27 in. (68.8 cm.); 6-1/2 in.
(16.5 cm.); 6-1/2 in. (16.5 cm.)
Collection of Mrs. Sue Niggeman

The Hemba produce a great
number of ancestor figures, the
overwhelming majority of which
are male. They are venerated by
a specific clan and kept in a
chief's house or special funerary
house. This example reflects, both
in pose and style, the kind of
serenity that ancestors are
believed to have. The ovoid head
and powerfully articulated body
parts express stability and
continuity of the lineage as well
as social authority and the right
to possess land.

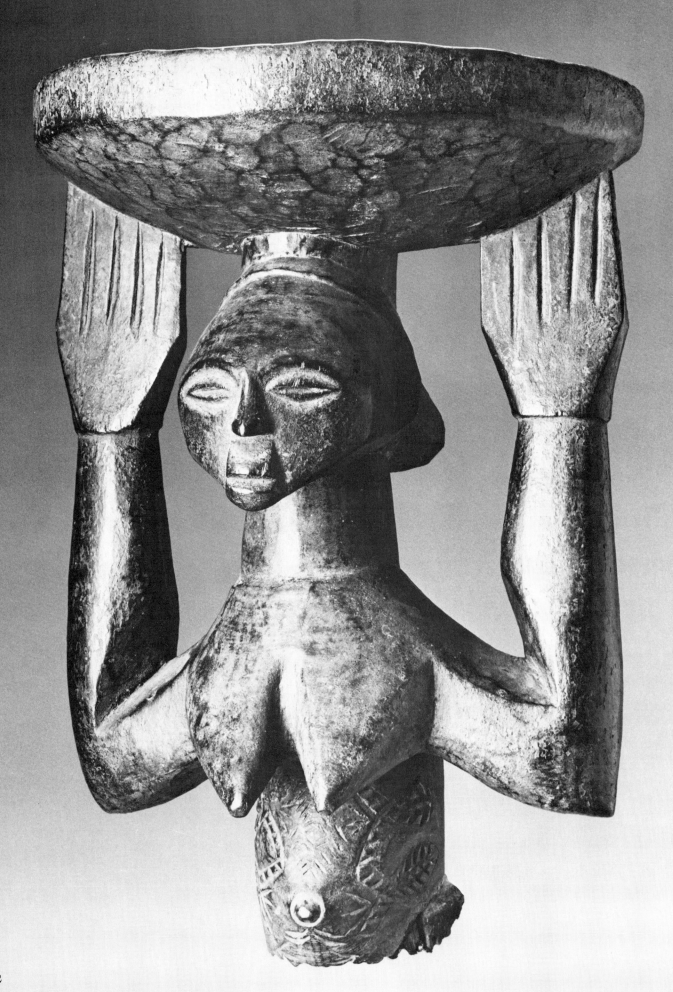

45 Stool

Luba, Zaire; 20th century
Wood
12-3/4 in. (32.5 cm.); 8-7/8 in.
(22.5 cm.); 8-5/8 in. (22 cm.)
Private collection

The art of the Luba centers
around ancestor figures and
fetishes. Of particular importance
in the art is the depiction of
females, probably because women
play such a prominent role in
creation myths and the origin
myths of the clan. It is interesting
to note that in Luba art females
are very rarely portrayed with
children. Often females serve as
caryatids on stools, which have
a potently symbolic and political
significance.

46 Male Figure

Luba (?), Zaire; 20th century
Wood
9 in. (23 cm.); 4 in. (10 cm.);
2-3/4 in. (7 cm.)
Private collection

The Luba have a long history of
war, with numerous kingdoms
vying for power and dominance.
Many believe that, as a
consequence, Luba art is a
reflection of various influences
and an intermingling of styles.
Most figural sculpture by the
Luba is female, although they do
make male divination figures that
surmount calabashes.
This male figure displays a
stylistic blend of Luba, Kusu, and
Songye elements.

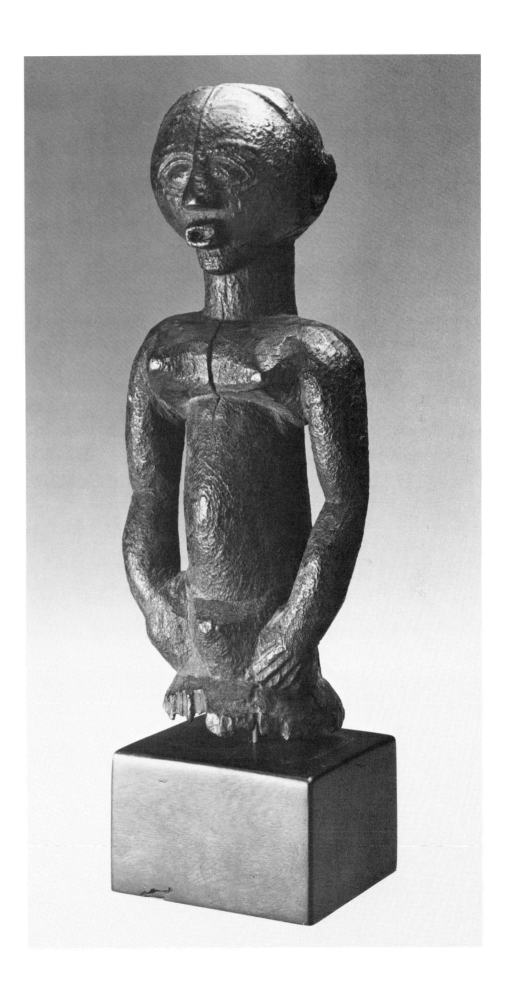

47 Male Figure

Boyo, Zaire; 20th century
Wood
16-1/8 in. (41 cm.); 5-1/2 in.
(14 cm.); 4-3/4 in. (12 cm.)
Ex-coll. Albert de Bailliencourt
Illustrated: *Arts d'Afrique Noire*
14, 1975, p. 5; and 11,
1974 (cover).
Private collection

There is much confusion
surrounding the differentiation
between the Boyo, Bembe, and
other groups living in eastern
Zaire; as a consequence their art
is not well understood. Royal
ancestor figures recalling
deceased village chiefs are the
most significant aspect of the
Boyo aesthetic tradition. Some
people believe that these figures
resemble the earliest ancestor
figures of the Luba, a similarity
resulting from the proximity of
the two groups at an earlier
time.

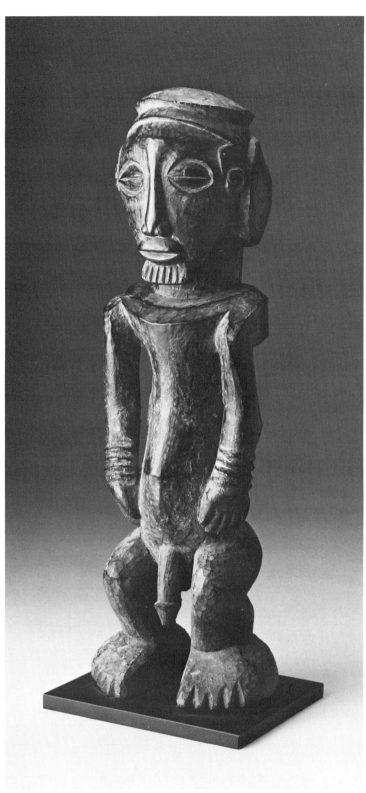

48 Double Vessel

Mangbetu, Zaire; 20th century
Ceramic
23-1/2 in. (59.8 cm.);
8 in. (20 cm.)
Collection of Dr. and Mrs.
Ralph Spiegl

This unusually fine
double-chambered vessel
depicting an aristocratic
woman probably served as a
trade or prestige object and
may date from the turn of the
century. The woman, depicted
with arms and breasts, has
an artificially elongated head
and hair design typical among
upper-class Mangbetu women.
The markings on her head
and body represent body
painting, which was well
developed among the
Mangbetu women.

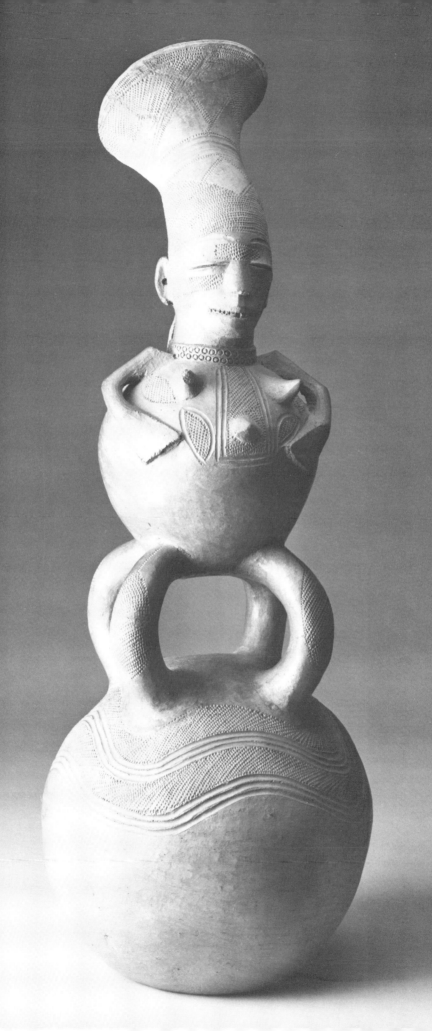

49 Male Ancestor Figure

Chokwe, Zaire or Angola;
late 19th century
Wood
22-1/2 in. (57.1 cm.); 5 in.
(12.6 cm.); 5 in. (12.6 cm.)
Private collection

This elegant figure depicting a
hunter probably represents an
idealized portrait of an ancestor
or hero. It is a piece of prestige
statuary done by a professional
sculptor working at his best.
Especially beautiful are the
deeply carved eye sockets,
elongated and fluid extremities,
and swirling headdress.
Illustrated: William Bascom,
*African Art in Cultural
Perspective*, New York,
W.W. Norton & Co., 1973, pl.
109, p. 151.

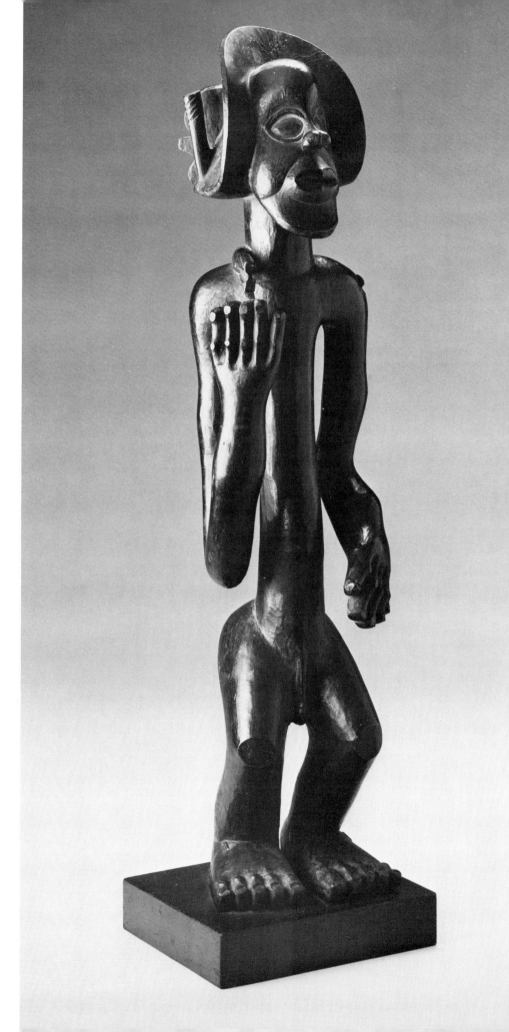

50 Carved Post

Madagascar, Malagasy Republic;
20th century
Wood
72 in. (83 cm.); 8-1/2 in
(21.5 cm.); 8-1/2 in. (21.5 cm.)
Private collection

Madagascar, the fourth largest
island in the world, is unique for
its homogeneity of language and
culture. The art of Madagascar
has been significantly influenced
by Indonesia through
longstanding trade contacts across
the Indian Ocean. Carved posts
were a major art form; they
were placed in tombs made of
rough-cut stones without mortar,
their number and motifs often
indicating the rank or wealth of
the deceased.

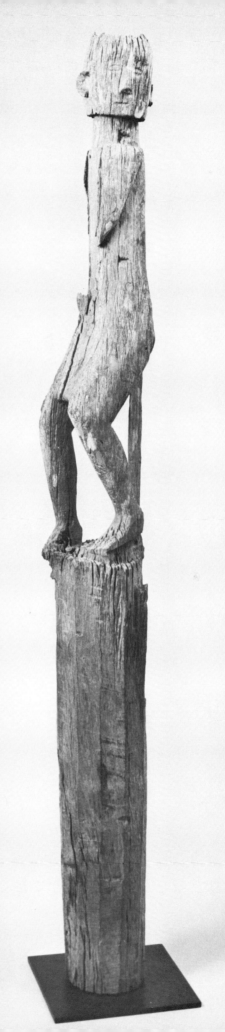

OCEANIA

51 Ancestor Figure *(Uli)*
Northern or north-central New
Ireland; 20th century
Wood, paint, shell, sea snail
opercula, fiber, and lime
42 in. (106.5 cm.); 10 in.
(25.5 cm.); 9-3/4 in. (25 cm.)
Private collection

Fantastic and elaborate carvings
characterize the art of northern
New Ireland, which is produced
for use in ceremonials called
malanggan. The word *malanggan*
actually means "carving," and the
ceremonials symbolize renewal
and replacement. The deceased
are honored at the same time as
the boys of the clan are initiated
into adulthood. The *malanggan*
carvings bear important clan
symbols which have specific
meanings to those involved in the
ritual but are not understood by
outsiders. *Uli* are hermaphroditic
ancestor figures characterized by
both phallus and breasts, fringed
beard, crest headdress, and a
lattice enclosure of ornamental
strips surrounding the body. They
are used in male rites which are
forbidden to women even as
observers. This piece, painted
red, white, and black, exhibits
the characteristic powerful
proportions and fierce expression.

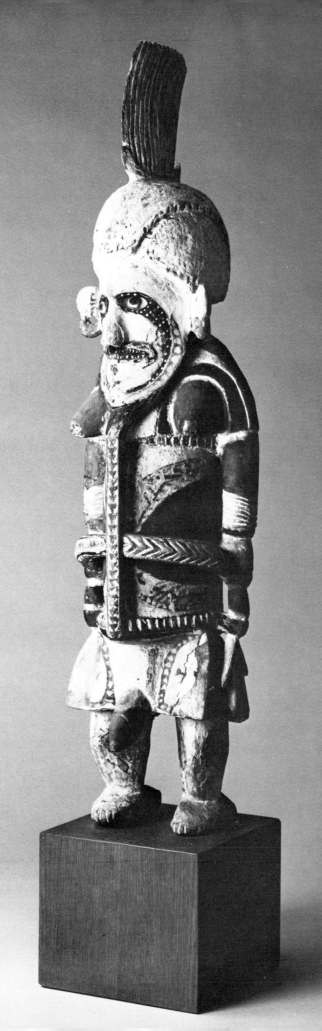

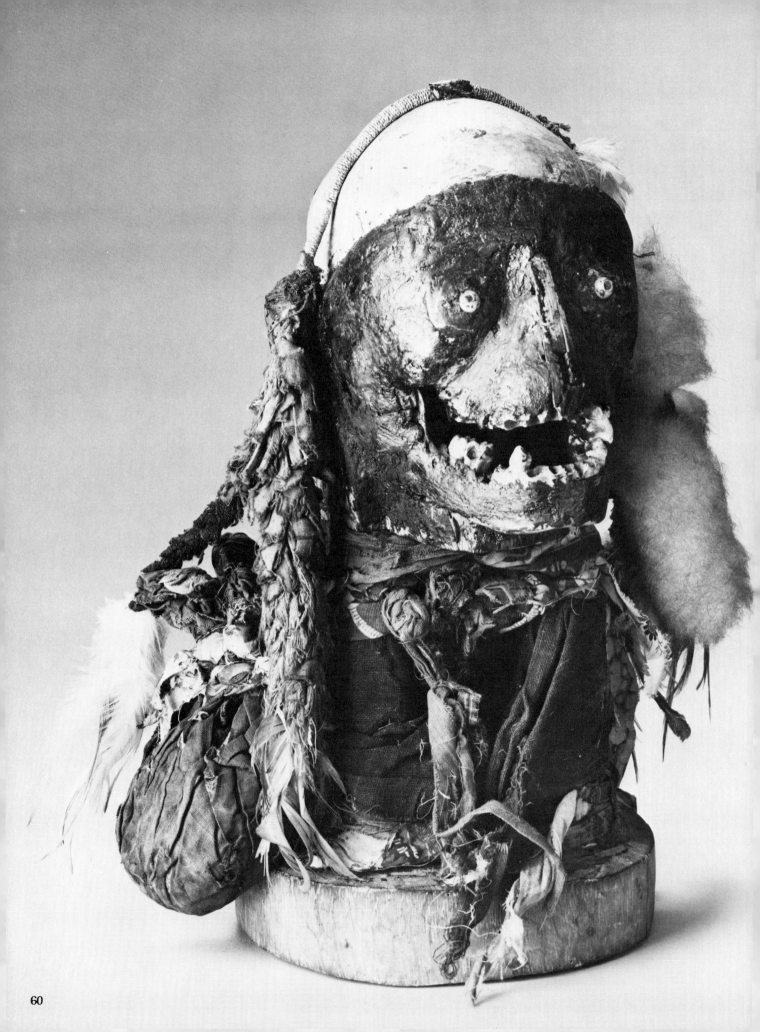

52 Mortuary Figure (Korwar)

Irian Jaya; early 19th century
Human skull, clay, wood, feathers, cloth,
and beads
14-1/4 in. (36.5 cm.); 11 in. (28 cm.);
9-7/8 in. (25 cm.)
Collection of Dwight Strong

Korwar figures from the northwest tip
of the island of New Guinea are
receptacles for the spirits of the dead
and are considered powerful mediums
of communication between the dead and
the living. Ritual requirements surround
the making of *korwar;* they are made
before an individual dies so that upon
death the spirit can enter the carving
immediately. Such figures are usually
kept at home, where they are venerated,
given offerings, and consulted for advice
on important matters. Some *korwar*
represent clan ancestors and are used
by the whole community. This example
is unusually powerful and elaborate for
its added materials and because it
actually incorporates the skull of the
ancestor inside. X-rays of the piece show
a fully carved wooden figure in
squatting position supporting the skull.

53 Face Mask

New Caledonia; late 19th century
Wood, paint, bits of adhesive,
and human hair
11 in. (28 cm.); 6 in. (15.2 cm.);
4 in. (10 cm.)
Collection of Bill Pearson

Face masks like this were part of a
much larger costume composed of
numerous long tufts of human hair and
black feathers attached to the holes
around the face. This dark costume,
sometimes embellished with red *abrus*
seeds, extended over the head and
around most of the dancer's body,
stopping near the knees. The dancers
have been documented as representing
water spirits in rites connected with
rain magic.

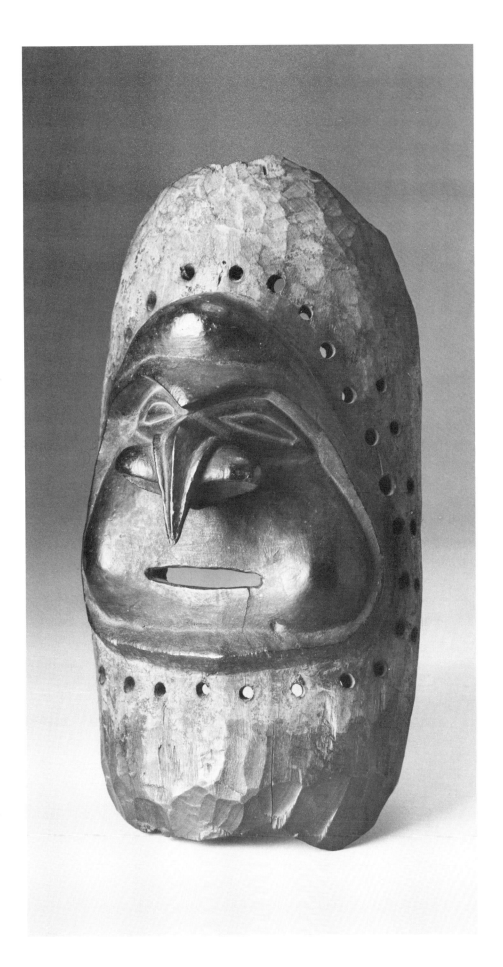

54 Stilt Step

Marquesas Islands; early 19th century
Ironwood
13-3/4 in. (35 cm.); 2-3/4 in. (7 cm.);
4 in. (10.1 cm.)
Ex-coll. H.G. Beasley
Private collection

Stilts were used in sports, races, and running games in the Marquesas Islands. They were comprised of a long shaft and a step (the latter often having a small human figure carved on it) and were bound together with tight sennit wrappings around the pointed end of the stilt step and through a wide slot at the figure's back. Smaller, somewhat similar objects were also made by the New Zealand Maori, who used them as sweet potato planting sticks.

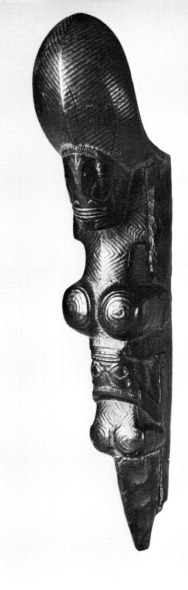

55 Neckrest

Tonga Islands; late 19th century
Wood and sperm whale tooth ivory
6 in. (15.2 cm.); 16-1/4 in. (41.2 cm.);
2-1/2 in. (6.5 cm.)
Private collection

Made from a single piece of wood with ten pieces of star and crescent-shaped ivory inlay, this neckrest is remarkable for its superb design and elegant craftsmanship. Neckrests were not widespread in Polynesia but were made in the Society Islands as well as in Tonga. They were used by royalty for lounging or sleeping.

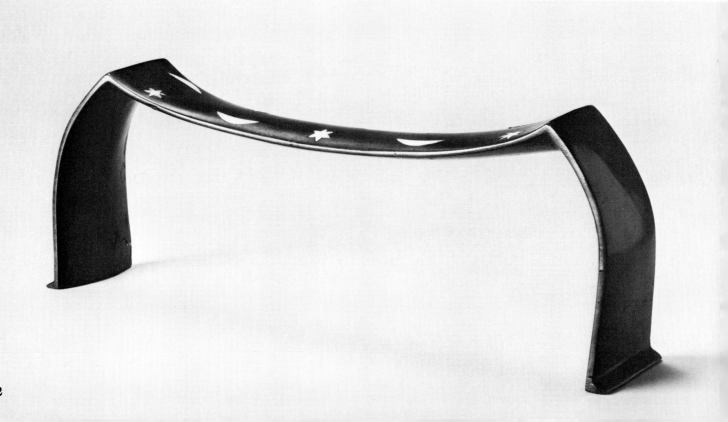

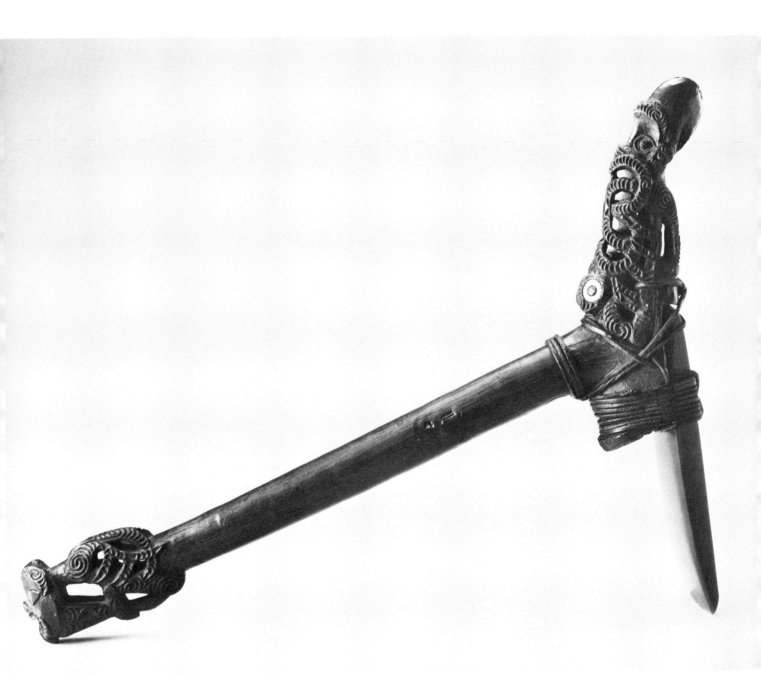

56 Ceremonial Adze *(Toki Pou Tangata)*
Maori, New Zealand; circa 1820
Wood, abalone shell, jadeite, and leather
21 in. (54 cm.); 13 in. (33 cm.)
Ex-coll. H.G. Beasley
Private collection

Ceremonial adzes were prized
possessions of the Maori royalty; they
were carried on ceremonial occasions,
used in oratory, or buried with Maori
chiefs. This elaborately carved example
is done in the Wanganui style of the
North Island. The original flax binding
that once held the blade to the carved
haft has long since deteriorated. It was
replaced in 1925 with a leather thong
added by the British Museum.

57 Flute *(Putorino)*
Maori, New Zealand; circa 1820
Wood with abalone shell inlay
21-1/2 in. (53.2 cm.); 2 in. (5 cm.)
Private collection

Flutes like this were blown bugle
fashion. They were made in two pieces
(front and rear) and were bound with
flax fiber in two or more places. This
piece is missing its original flax
bindings. Carved in a North Island
style, it may be one of the oldest
examples of its type in existence.

58 Breast Ornament *(Hei Tiki)*
Maori, New Zealand; 19th century
Nephrite
5-1/4 in. (13.5 cm.); 3-1/4 in. (8 cm.)
Collection of Bill Pearson

Ornaments such as this were highly
prized among the Maori; they were
prestige objects and frequently heirlooms
in aristocratic families. The compacted
shape of the *hei tiki* often conforms to
the shape of adze blades. This is
because many examples were in fact
carved from stone adze blades after
metal tools were adopted. *Hei tiki* often
took months to create, owing to the
difficulty of working the material. This
example displays the curious
three-fingered hand found on many
Maori carvings. It also depicts female
genitalia, which occur on about one out
of four examples.

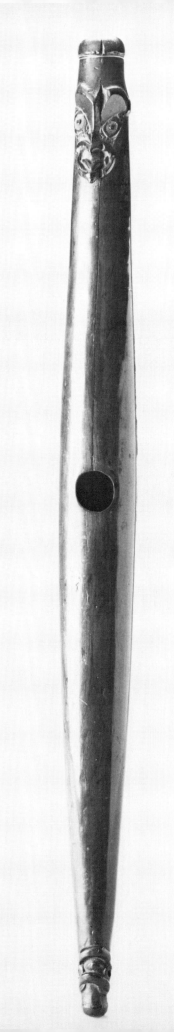

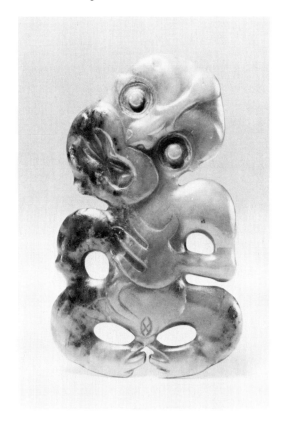

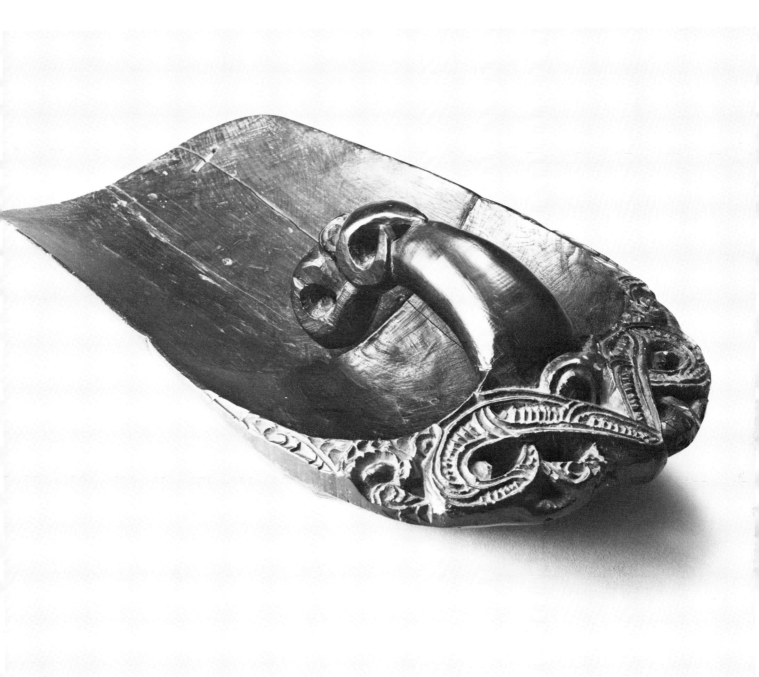

59 Canoe Bailer *(Tata)*
Maori, New Zealand; 1830s
Wood
18-1/4 in. (45.6 cm.); 10 in. (25.4 cm.);
5 in. (12.7 cm.)
Private collection

This is a very fine, well-patinated example of a war canoe bailer, more elaborate than most, which incorporates the head of a *manaia* or bird-like mythological creature within the carving. Remnants of a native repair are seen across the end of the bailer. When splits occurred, the Maori would repair them by drilling holes and binding the split with flax fiber. The function of the central ridge across the bailer is unknown, but many examples have this feature. Bailers for important canoes were given personal names and were often cherished possessions.

60 Bark Painting depicting *The Opossum
Tree Story*, by Nanin
Australian aborigine, Yirkalla Region,
Arnhem Land; 20th century
Stringybark eucalyptus and
natural pigments
47-1/4 in. (120 cm.); 23-1/4 in.
(59 cm.)
Collection of Louis A. Allen

Intricately detailed bark paintings were
used to instruct young men in the
mythical heritage of their clan. This
painting represents one of the oldest
stories in Arnhem Land. In the time
before morning, the night bird Karawak
became lonely and went looking for his
friend the ringtail opossum Murango.
He found him at several places, but
Murango would not speak because it
was daylight. At nightfall, Karawak
reached the totemic tree at Djerakoi,
where he heard Murango moving about
inside. This time, because it was night,
Murango came to join him, and they
sat talking and looking at Gunyan the
crab on the beach below. This is why
the night bird calls only at night, as he
knows this is the only time Murango
will answer. The painting repeats main
elements of the story for emphasis. It
was collected by Dr. Stuart Scougall.

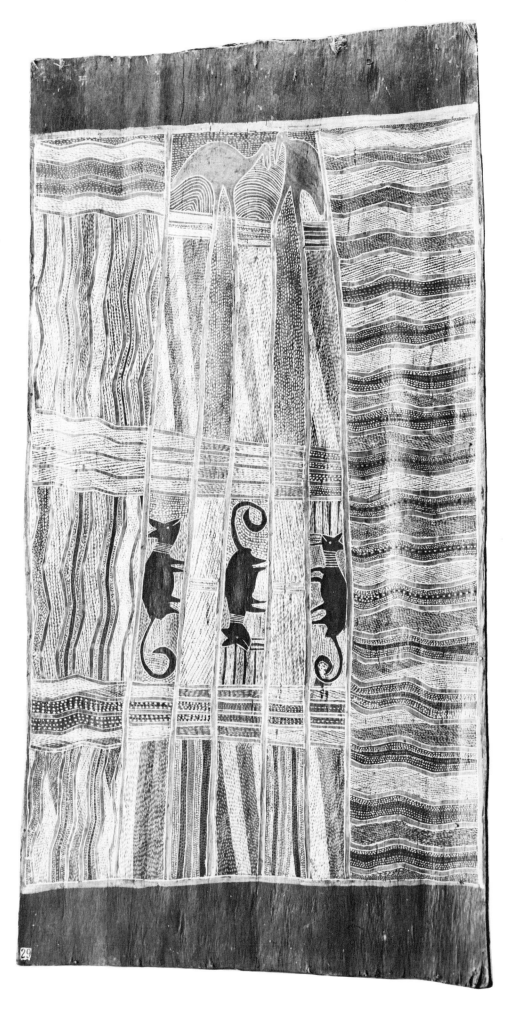

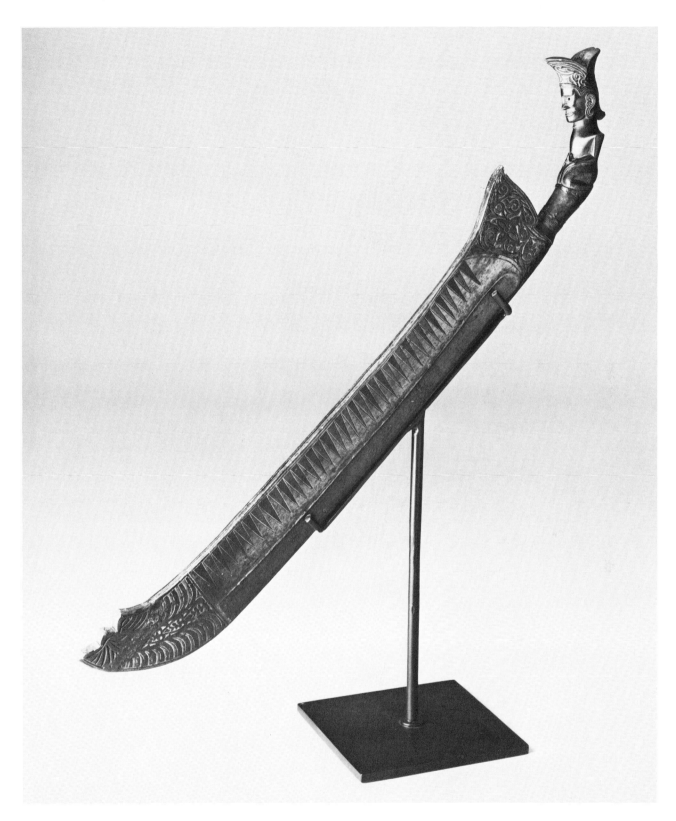

61 Sword

Batak, northern Sumatra; late
19th century
Bone, iron, and wood
23-3/4 in. (60 cm.); 4 in. (10 cm.)
Collection of Mrs. Sue Niggeman

This beautifully carved sword and its carved wooden sheath painted in red and black display the elegance and serene detachment that typify much of Batak carving. Sitting or kneeling figures with arms pressed close to the body frequently decorate priestly staffs. The richly detailed hat on this figure, its spiral decoration echoed in the wooden sheath, is especially elaborate. Rhythmic too are the gentle planes and curves of intertwining body parts which reflect influences from India and the Orient.

NORTH AMERICA

62 Swaixwe Mask
Coast Salish, probably Cowichan of
South Vancouver Island; 20th century
Wood and paint
26-3/4 in. (68 cm.); 11 in. (28 cm.);
8-7/8 in. (22.5 cm.)
The Loran Collection

Power masks representing the guardian
spirit of Swaixwe (or Sxwayxwey), are
used in important rituals performed to
gain this spirit's help in future
endeavors. The individual seeking the
help of Swaixwe must experience
ordeals such as purification and fasting
before he will be granted the power to
become a great warrior, gain wealth, or
cure a sick person. The mask is worn
or held at an angle so that the mouth
openings serve as eye holes. This
example is painted in red, white, and
black and, like many Swaixwe masks,
makes use of bird forms for the ears
and nose.

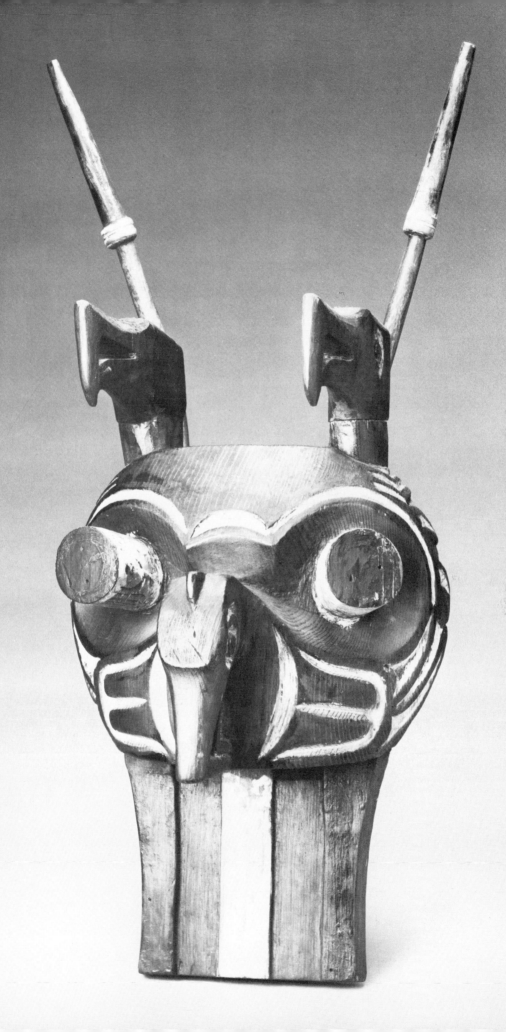

63 Spoon

Haida(?), Northwest Coast Indian;
20th century
Mountain goat horn, mountain sheep
horn, and copper
17-1/2 in. (44.4 cm.); across bowl 7 in.
(17.8 cm.); 7-1/2 in. (19 cm.)
Private collection

Decorated spoons or ladles were used
during feasts for dipping oil and food
from ceremonial feast bowls. The
artistry and technology with which such
spoons were produced was complex.
The horn of sheep or goats (sometimes
both, as in this example) was steamed
and bent to shape; a metal plate and
rivets, usually copper, were used for
joining. The handles and sometimes the
bowl of the spoon were carved with
family crests, and the tip of the handle
often formed the beak of the raven.
These treasured possessions were
sometimes inlaid or decorated with
abalone, bone, or ivory.

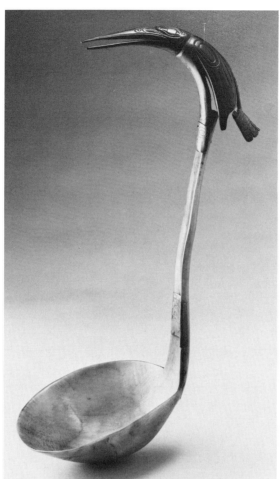

64 Woven Chief's Hat

Bella Bella (Northern Kwakiutl),
Northwest Coast Indian; circa 1880
Spruce root and paint
7 in. (17.8 cm.); 14 in. (35 cm.)
Collection of Mr. and Mrs.
Grant Winther

Twined basketry hats of spruce or cedar
root were worn by the Indians of the
Northwest Coast as a protection against
rain. This hat belonged to an
aristocratic individual, as only the
wealthy could wear hats with designs.
The decoration on this example depicts
a frog (a creature believed to have
magical qualities) wrapped or spread
out around the hat's exterior in a
stylistic convention common to the
Northwest Coast Indians. Generally, hats
were woven by women, and the men
painted the designs. The combination of
the floating eye design, the arrangement
of the figure, the shape of the crown,
and the skip stitch design on the brim
are evidence that this is a Northern
Kwakiutl hat.

65 Lidded Storage Box

Bella Bella (Northern Kwakiutl),
Northwest Coast Indian; circa 1890
Cedar and native paint
24-1/4 in. (61.6 cm.); 21-1/2 in.
(54.6 cm.); 17-1/4 in. (43.8 cm.)
Collection of Mr. and Mrs.
Grant Winther

Boxes were made by many Northwest
Coast Indian groups for purposes of
storage, cooking, and cremation. The
boxes were ingeniously made by
kerfing, a method by which a single
plank of wood was steamed and bent to
form three corners of the box, the
fourth corner being joined by pegging
or sewing. The bottom of such
containers was a separate piece of wood
attached with pegs, or nails when
available. Often a lid was made to fit
the top. The lids were never painted or
carved but on occasion would be inlaid
with shell. The type of box shown here
was made to store household
possessions such as clothing, heirlooms,
or blankets. Stylized crest figures and
occasionally human faces were painted
in red and black, most often on the
front and back of the boxes, with
smaller, simpler motifs on the sides.

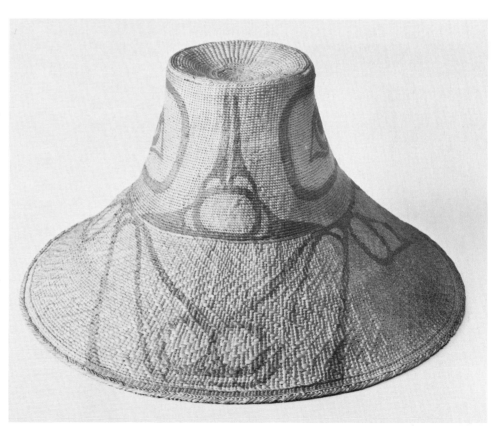

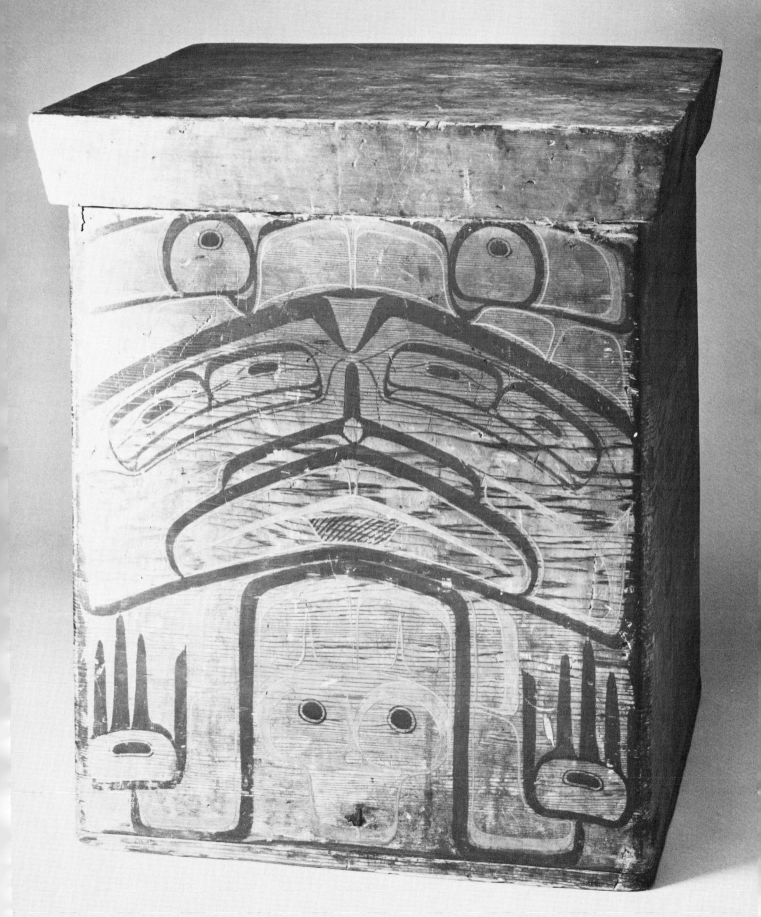

66 Chilkat Blanket

Tlingit, Northwest Coast Indian;
circa 1900
Mountain goat wool, cedar bark, sinew
thread, muslin ties, and natural dye
53 in. (134.6 cm.); 70 in. (177.8 cm.)
Collection of Mr. and Mrs.
Grant Winther

The term "Chilkat blanket" refers to a
type of finely woven blanket or status
garment that was worn around the
shoulders of chiefs and other aristocratic
individuals for ceremonial occasions.
The name of the blanket is of European
origin, probably because for many
generations a single division of the
Tlingit called the Chilkat were the only
ones making the blankets. To create the
weaving, the men supplied the goatskin,
loom, and pattern board with design.
The women prepared the wool yarn,
the cedar bark, and dyes and then
worked to weave the blanket in twined
tapestry. The combination of materials is
complex: the woof and the covering of
the warp are mountain goat wool, the
inner warp is fashioned from the inner
bark of cedar, and the uniting element
used to join the various weaving
divisions is the sinew of caribou or
whale. The design on this example is a
very old Chilkat pattern which dates
from the mid-eighteenth century. It has
been interpreted as either a killer whale
or the sea monster Gonaqadet.

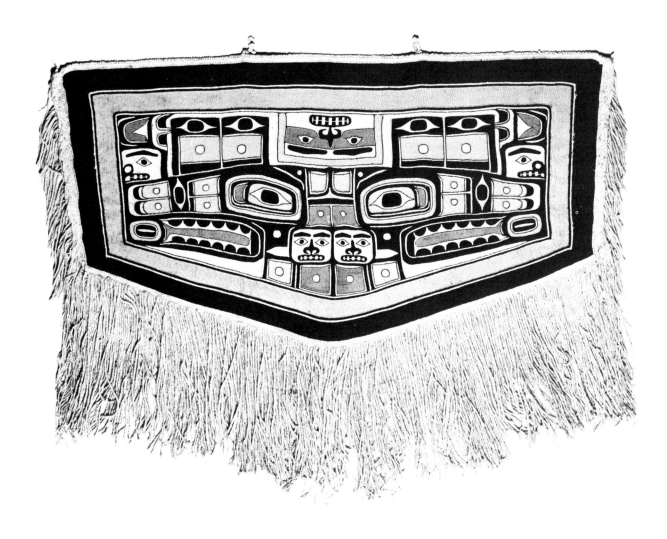

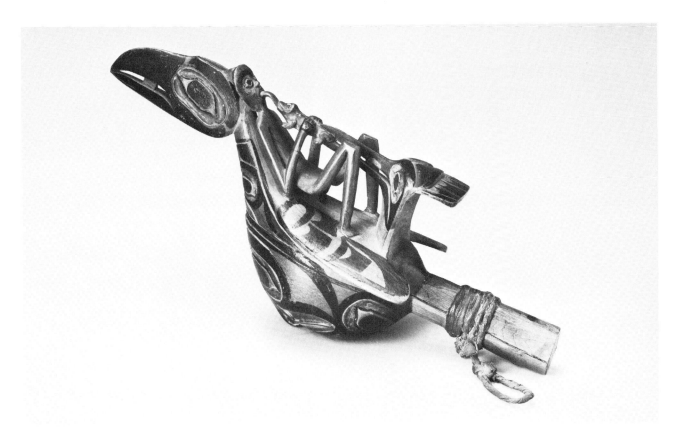

67 Raven Rattle

Tlingit, Northwest Coast Indian;
late 19th century
Wood, paint, and fiber
12-3/4 in. (32.4 cm.); 4 in. (10.1 cm.);
5 in. (12.6 cm.)
The Loran Collection

Carved in the shape of a raven, this
type of wooden rattle is used by the
chief or headdress dancer in winter
ceremonials. It is held low and to the
side, and constantly kept in a vibrating
motion with the rattle in a position that
would appear to us to be upside down.
A rattle such as this would be among
the ceremonial equipment, songs, and
privileges handed down in a family
from generation to generation. This
raven rattle follows the traditional form.
On the raven's back are two figures, a
shaman (or healer with supernatural
powers) and a frog (considered a
magical creature) who are touching
tongues in a pose which is generally
interpreted as a transfer of power. The
breast of the raven carries the
traditional hawk design. In the raven's
mouth is the sun. The rattle is carved
in two halves to be joined later and is
painted in black, red, and blue-green.

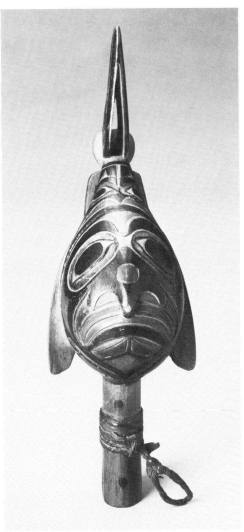

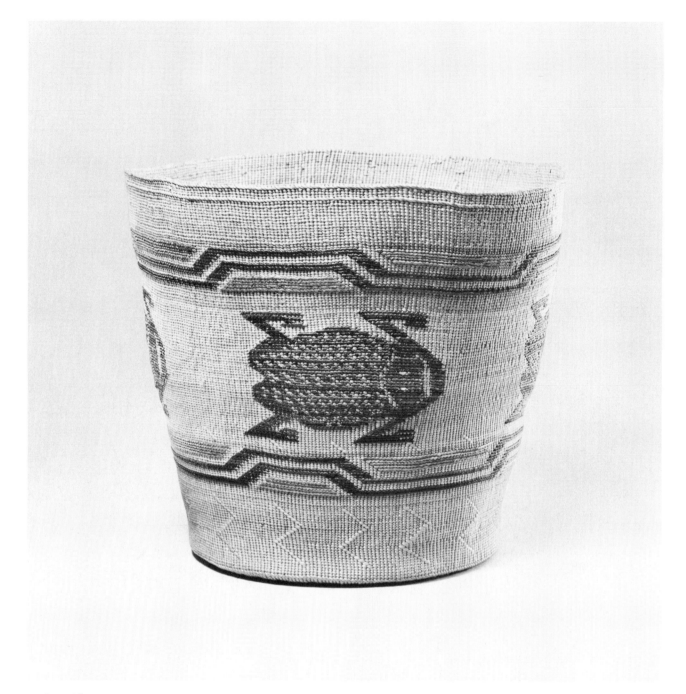

68 Basket with Frogs

Tlingit, Northwest Coast Indian;
19th century
Spruce root, grasses, other fibers
6-1/2 in. (16.5 cm.); 7-1/2 in.
(17.8 cm.)
Collection of Bill Pearson

Among the Tlingit, baskets were made
by the twining method, with "false
embroidery" decoration added in various
colors. Most Tlingit baskets have bands
of geometric decoration on their
exteriors; this example is unusual for its
four bold images of realistic frogs. In
near-perfect condition, the basket
contains a note that provides a
delightful historical sidelight: "This
basket was bought by Aunt Emeline on
the trip to Florida with Uncle John,
Uncle Edwin and Aunt Mary Bindley,
she bought the aligator [sic] in the
same trip."

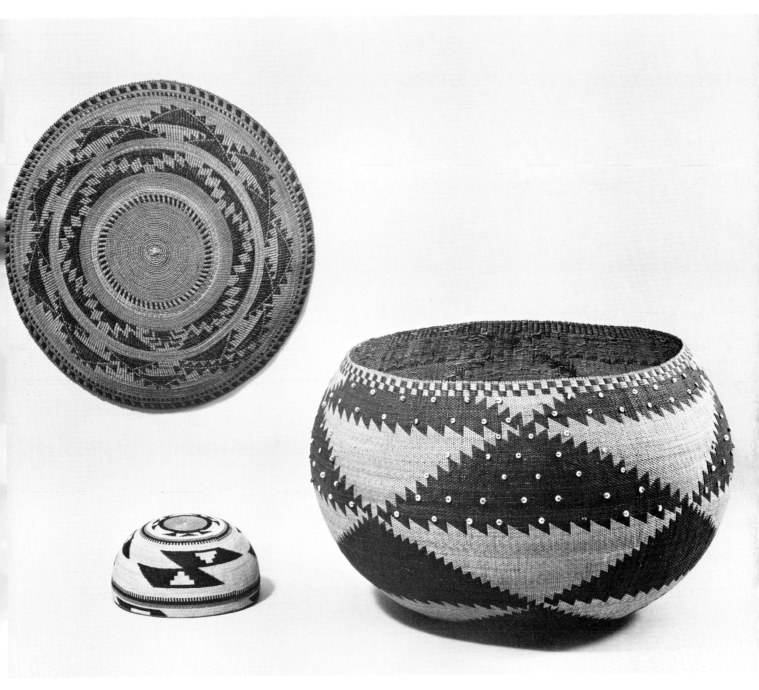

69 (bottom left)
Woman's Cap
Yurok, California Indian; early
20th century
Willow shoot, bear lily, and
maidenhair fern
3-1/4 in. (8.2 cm.); 7-1/4 in.
(18.4 cm.)
Private collection

This exceptionally fine example of a
dress hat was worn by Yurok women
for public functions. Many rules govern
the design layout of a Yurok woman's
cap: three rows of brown twining were
required in two places, and the
weaver's palm width defined the
dimensions and spacing of various parts
of the design. The design had to be
equally spaced throughout, and the
weaver had to count the warps to make
sure of its exact placement.

70 (above left)
Lattice-twined Basket (*Dala*)
Northern Pomo, California Indian;
early 20th century
Willow shoot, sedge root, and split
redbud shoots
4 in. (10.1 cm.); 16-5/8 in. (43 cm.)
Private collection

Lattice-twined baskets such as this were
used for segregating corn meal and
winnowing seeds. The *dau* pattern or
break in the design, which occurs on
many horizontal bands of Pomo baskets,
is required by myth. Spider Woman,
who taught weaving to the Pomo,
inspects each basket pattern with her
fingers after it is completed. The weaver
will go blind if the *dau* pattern is
not made.

71 (right)
Food Storage Basket with Beads
Pomo, California Indian; early
20th century
Willow shoot, sedge root, split redbud
shoots, and clam shell beads
19-1/2 in. (49.5 cm.); 12 in. (30.5 cm.)
Private collection
Large baskets made for food storage
were twill twined. They were used for
keeping dried fish, acorns, and seeds.
Those made for wedding gifts, as was
this example, had clam shell beads
attached to their exteriors.

72 Kachina *(Hemis Kachina)*
Hopi Indian, southwestern
United States; 20th century
Cottonwood root, paint,
and feathers
19-1/2 in. (49.5 cm.); 7-1/4 in.
(17.8 cm.); 3-3/8 in. (8.2 cm.)
Collection of Herschel B. Chipp

Kachinas are Pueblo Indian
messenger spirits to the gods,
and the most prolific carvers of
them are the Hopi Indians. In
Hopi culture, kachina dancers
appear in the villages after the
winter solstice to perform rain
and fertility rites as well as other
ceremonials to promote village
well-being. Kachina figures are
traditionally carved by men who
give them as gifts to Hopi girls
during public kachina
ceremonies. The carvings perform
a didactic function and to some
extent allow more female
participation, since only men can
wear the masks and perform
kachina dances. The Hemis
Kachina, represented by this
carving, is named for the Jemez
Pueblo on the Rio Grande (where
it is said to have originated) and
often appears in the last
ceremony of the year before the
kachinas go home. The design on
the terraced *tableta* headdress
depicts a cloud with rain and a
rainbow (signifying fertility). The
tableta is topped with feathers,
which carry prayers upward, and
the double crescents painted on
the body are signs of friendship
and peace. The black paint
derives from the Hemis Kachina
dancers' use of corn smut to
blacken their bodies, and the
ceremonial dance kilt, sash,
leather arm bands, and red
moccasins are
all shown.

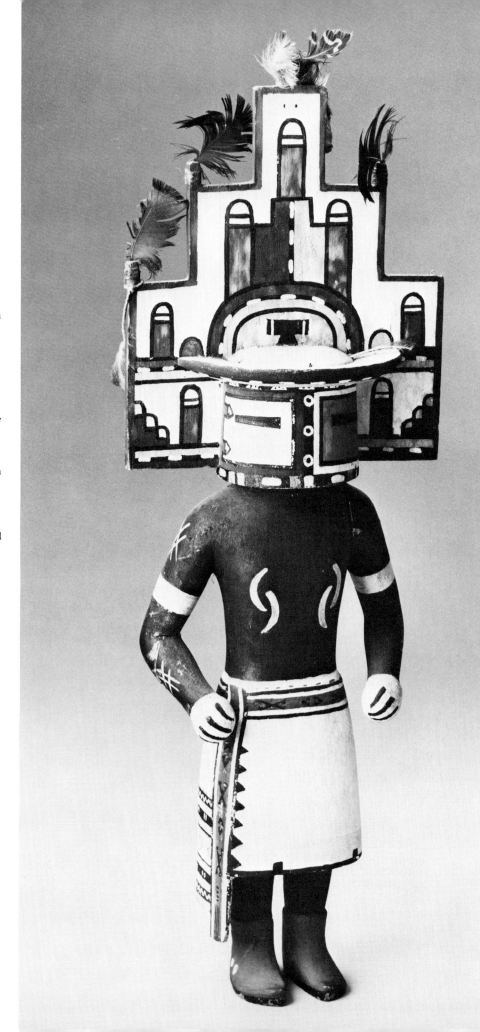

73

Kachinas *(Tihus)*
Hopi Indian, southwestern
United States; 1890-1910
Cottonwood root, paint, string,
and traces of feathers
Left: 7-1/2 in. (19 cm.);
3 in. (7.6 cm.)
Center: 8-3/4 in. (22 cm.);
5 in. (12.8 cm.)

Right: 9-3/4 in. (25 cm.);
3 in. (7.6 cm.)
Collection of Susan J. Smith
and Fred W. King

These three kachinas probably
date from the turn of the century.
The smallest one is painted in
red, black, and white and

represents Kachina Mother
(Hahai-i Wuhti), who is
considered mother of all
kachinas; she performs ritual
duties and does not dance. The
multi-colored kachina in the
center, painted red, black, yellow,
and white is Cloud Kachina

(Oman-u), identified by the cloud
pattern on the cheeks, and
represents a style that was rarely
made after 1915. The tallest
kachina is painted in orange,
white, and black and represents
Duck Kachina (Pawik).

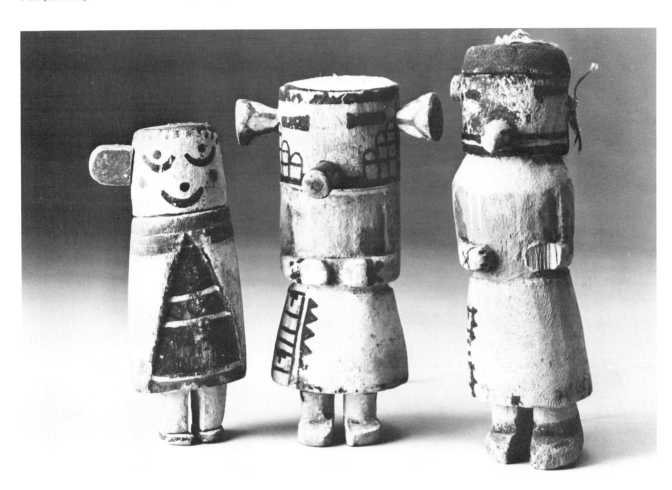

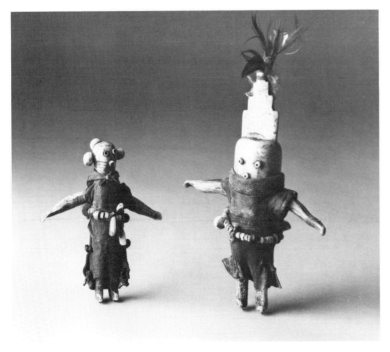

74 Fetishes
Zuñi Indian, New Mexico;
20th century
Deer horn, feathers, turquoise
beads, shell, and leather
Left: 4-1/2 in. (11.5 cm.); 4 in.
(10 cm.); 1-3/4 in. (4.5 cm.)
Right: 8-3/4 in. (22 cm.); 5 in.
(12.5 cm.); 2 in. (5 cm.)
Collection of Mr. and Mrs.
Charles Campbell

Sometimes called altar dolls and
representing kachinas, Zuñi
fetishes are regarded by their
makers as powerful living entities
which must be carefully tended.
They were usually housed in
special pottery jars and
ceremonially fed through a hole
in the jar's side. More rarely,
figures such as these were
attached to the outside of jars.
Particular societies or cults used
them in connection with war,
initiation rites, curing,
or protection.

75 Bowl

Mimbres, prehistoric
New Mexico; 1050-1200 A.D.
Clay and paint
2-3/4 in. (7 cm.); 6-5/8 in.
(16.75 cm.)
Collection of Mr. and Mrs.
Charles Campbell

People from all three of the major southwest prehistoric groups—Mogollon, Hohokam, and Anasazi—produced pottery, presumably for practical and ritual uses. The pottery made by the Mimbres branch of the Mogollon culture is the most spectacular exponent of the southwest pottery tradition. Mimbres black-and-white bowls such as this example are astonishing for their variety of depiction as well as the detail in which they are rendered. Here, what appears to be a delightful four-legged creature on closer inspection seems to combine animal and human appendages. The precise significance of the animal-clawed forepaws and human-footed hind legs, as well as the cross-hatched motif that stretches across the back of the animal, remains unknown. Most Mimbres pots have ritual kill holes, which were made at the time of interment.

78 Mask for Dance of the Dwarfs

Nahua, La Parota area, Guerrero;
early 20th century
Zompantle wood and paint
39 in. (99 cm.); 17-1/2 in.
(44.5 cm.); 9-1/2 in. (24 cm.)
Ex-coll. Donald and
Dorothy Cordry

Collection of Robert Lauter
The Dance of the Dwarfs is usually performed on May 3 of each year at the beginning of the rainy season. The mask and the related ceremony are closely related to the Aztec rain god, Tlaloc. Dance masks like this are worn by small boys who frequently perform in caves to honor the god of rain. Various water symbols are incorporated into the mask: the rippling beard, the green snake, and the similarly colored eyes.

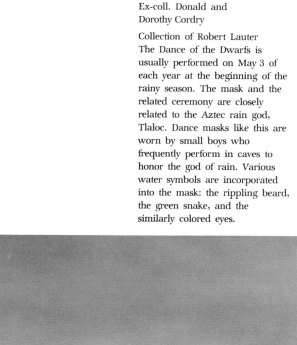

76 Storage Jar, María Montoya
Martinez (1887-1980)
San Ildefonso Pueblo,
New Mexico; early 20th century
Ceramic and paint
9-1/2 in. (24 cm.); 11 in.
(28 cm.) diameter
Private collection

María Martinez and her husband Julián are certainly the most famous Pueblo Indian potters; this jar was made by María before her blackware period and is characteristic of the traditional polychrome style of San Ildefonso. The floral pattern is worked in black and white on the upper two-thirds of the vessel; the bottom and interior are red ochre.

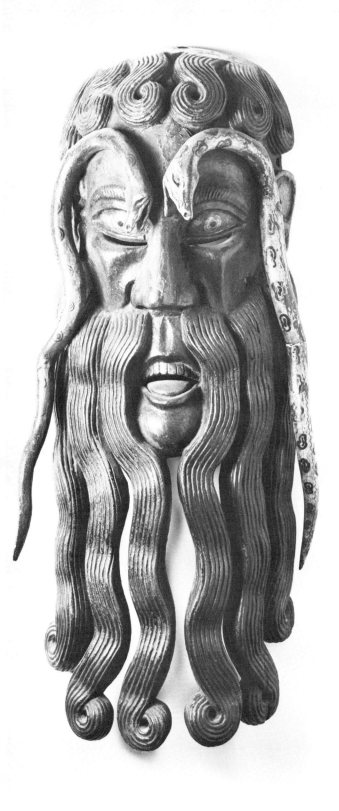

79 Death Mask

Nahua, Apanga, Guerrero;
late 19th century
Bone, shell, wood and paint
14 in. (35.5 cm.); 9-3/4 in.
(25 cm.); 11 in. (28 cm.)
Collection of Robert Lauter
and Elizabeth Burstein

This very rare type of death
mask is used in such dances as
the *Tres Potencias* (Three
Powers), Day of the Dead, Bat
Dance, Apache Dance, and
certain devil dances. The wooden
helmet is completely covered with
an inlaid mosaic of bone and
shell. Black and white details are
painted for emphasis. Flowing
over the head of the mask is a
representation of Quetzalcoatl as
a feathered serpent. The split
nose is a symbol related to
Xolotl, the Pre-Columbian god of
death and duality.

**77 Mask for Dance of
the Marquez**

Nahua, Coatepec Costales,
Guerrero; early 19th century
Cedar and paint
15-1/2 in. (38.7 cm.); 8 in.
(20.2 cm.); 5 in. (12.7 cm.)
Collection of Robert Lauter
and Elizabeth Burstein

The Dance of the Marquez is a
variant of the popular dance
known as the Dance of the
Moors and Christians. These
dances were taught to the
Indians by the Spanish clerics
from the time of the Conquest in
an attempt to convert them to
Christianity. The dances represent
a blend of traditional Indian
ceremonies and Christian or
Spanish elements.

MESOAMERICA AND SOUTH AMERICA

80 Seated Figure Holding Ball
Olmec, Las Bocas, Puebla,
Mexico; 1150-550 B.C.
Ceramic and paint
11-1/2 in. (29.1 cm.); 10 in.
(25.5 cm.); 5 in. (12.6 cm.)
Private collection

The Olmec evidently believed that
a woman cohabited with a
jaguar, their union producing a
race of jaguar-babies. Figures like
this with infantile features have
been called the "jaguar's
children." Many of them are
seated, sexless, with arms
upraised; others have been
depicted in various stages of
crawling. Most have been found
in pieces, possibly indicating that
they were ritually broken or
smashed. The significance of the
incised hollow ball held in the
right hand of this unusual and
important example is unknown.
There are traces of red pigment
on the head, hands, feet,
and ball.

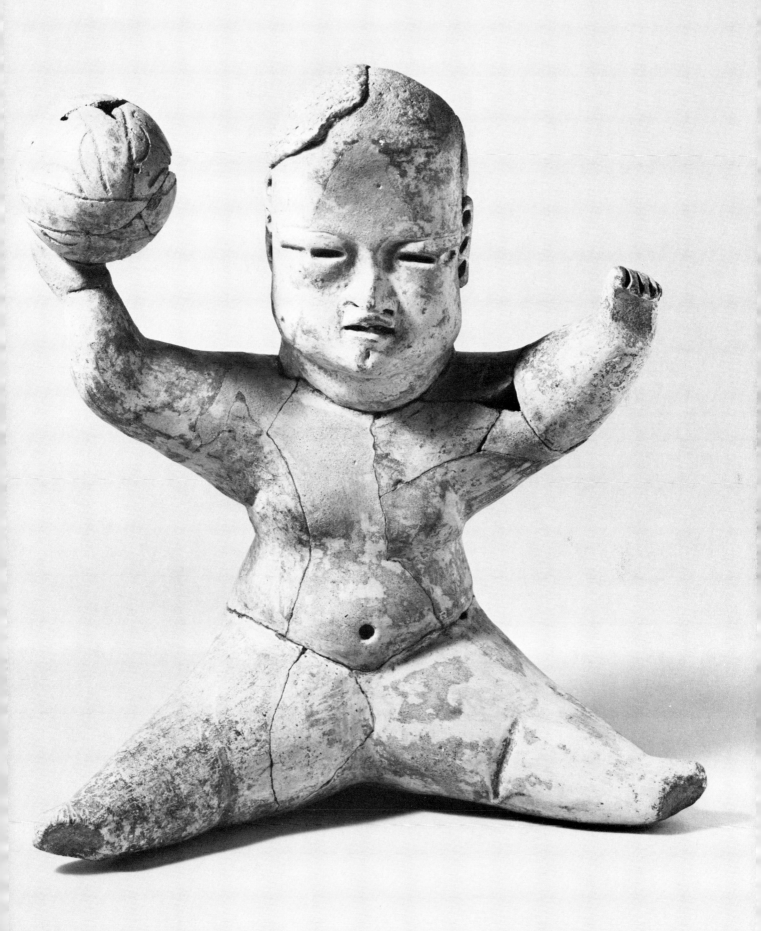

81 Standing Figure

Olmec, Gulf Coast, Mexico;
1000-300 B.C.
Greenstone
4-3/8 in. (11 cm.); 1-1/2 in.
(4 cm.); 1 in. (2.5 cm.)
Private collection

Small figures of jade or greenstone have been found as far afield from the Gulf Coast of Mexico (Veracruz) as Guerrero, the highlands of Guatemala and even Costa Rica. They possibly served as trade objects in this very early period in Mesoamerica. Generally, such figures are associated with the were-jaguar, a creature with human and animal elements which was prominent in Olmec myth-history or religion. The misshapen head and distinctive features on this example are typically Olmec.

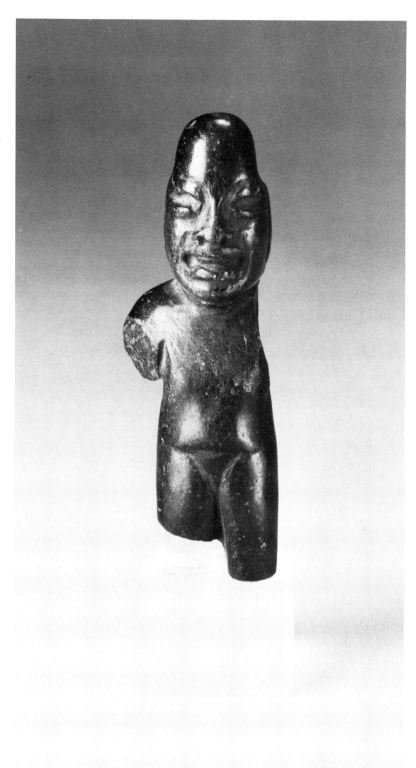

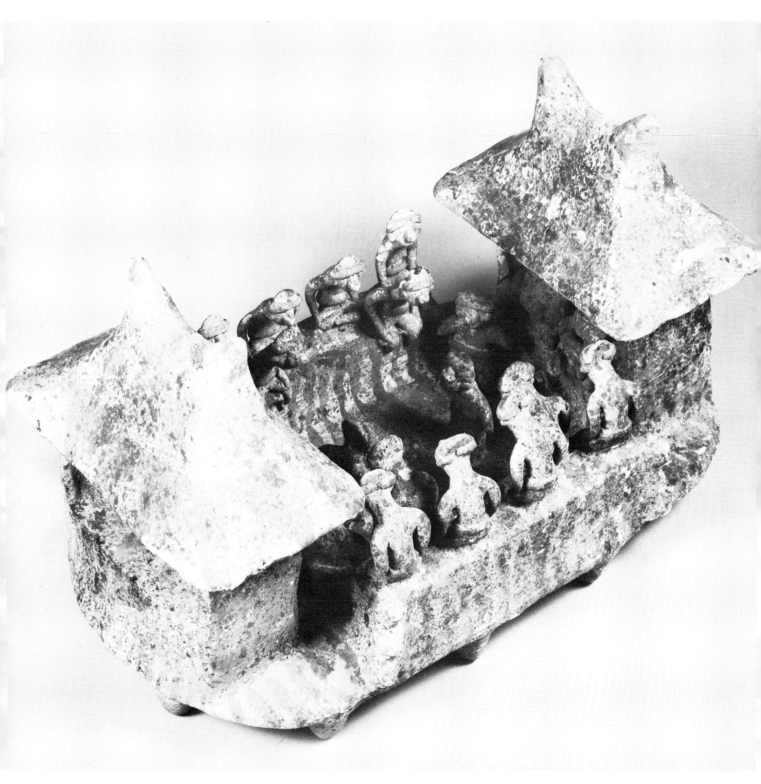

82 Ball Court Scene
Nayarit, West Mexico;
200 B.C.-330 A.D.
Ceramic and paint
9 in. (22.9 cm.); 8-1/4 in.
(21 cm.); 14 in. (35.5 cm.)
Private collection

The early ball game in West Mexico is documented by clay models such as this which depict it as a largely secular game, differing radically from the religious event involving human sacrifice that was played throughout much of Mesoamerica. This example shows the private court of an upper-class *ranchero*, with two end-houses on raised platforms, each with a peaked thatch roof. In each end-house, a male sits arm-in-arm with a female. On the marked court are six players, three on each side, who can propel the ball only through use of their shoulders, hips, buttocks, or knees. A total of twenty-two figures are involved in the scene. The sculpture is modeled in buff clay on a footed slab and is painted in red, black, and white.

83 Male Figure
Southern Nayarit, West Mexico;
100-500 A.D.
Clay and paint
17-1/4 in. (44 cm.); 9 in.
(22.9 cm.)
Private collection
Large hollow figures from
southern Nayarit shaft tombs are
sometimes polychromed and often
dramatically sculpted. Gigantic
legs, disproportionately small
arms, elaborate body paint, and
jewelry give these figures a
surreal presence that sometimes
approximates caricature. Musical
instruments such as rasps, rattles,
whistles, flutes, and drums
frequently accompany male
figures in the sculpture of West
Mexico. The white painted
patterns on this example most
likely represent body paint.

84 Joined Couple
Southern Nayarit, West Mexico:
200 B.C.-330 A.D.
Ceramic and paint
12 in. (30.5 cm.); 11 in.
(28 cm.); 9-1/2 in. (24.1 cm.)
Private collection

This masterful and unique work
catches an intimate moment
between a seated male and
female. The man's arm curves
around the woman's shoulder as
he leans forward to whisper in
her ear. She has edged even
closer, cocking her head to one
side. The man proffers a cup;
both figures are naked, with
elaborate body paint. Although
the woman's hairline is incised,
she otherwise appears to be quite
bald, and the bones of her back
are vividly depicted (possibly
indications of age or ailment).
The technical handling of the
media is remarkable.
Illustrated: H.B. Nicholson and
A. Cordy-Collins, *Pre-Columbian*
Art from the Land Collection.
San Francisco: California
Academy of Sciences and
L.K. Land, 1979, color plate 16.

85 Ritual Perfomer

Colima style, West Mexico;
200 B.C.-500 A.D.
Ceramic
8 in. (20.2 cm.); 3 in. (7.6 cm.);
4 in. (10.2 cm.)
Collection of Dr. Gerald Lutovich

Figurines such as this, reportedly found in the same shaft tomb chambers as the larger, hollow figures, illustrate a wide variety of cultural activities in vivid detail. This male figure represents a dancer in full regalia who carries rattles in his hands. Frequently, figures of this sort are themselves musical instruments; this example does in fact whistle when blown into through a hole behind the head.

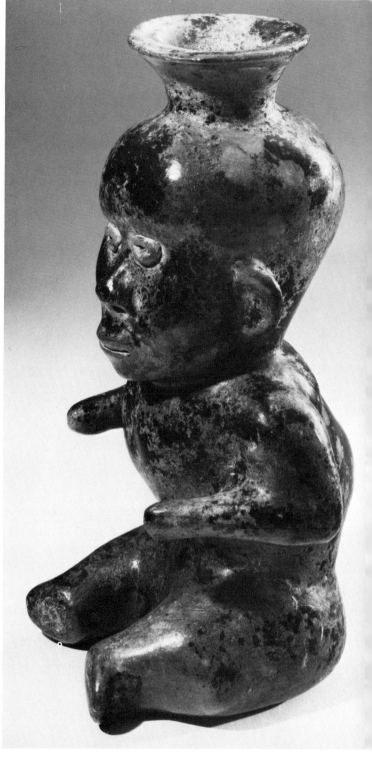

86 Hunchback Dwarf

Colima, West Mexico
Ceramic
10 in. (25.4 cm.) 5-1/2 in.
(14 cm.)
Collection of Ernest B. Ball

This highly polished representation of a hunchback has a juglike opening on the top of the head and is completely hollow inside. Colima sculptors portrayed a wide variety of individuals drawn from everyday life, sometimes representing deformities or diseases. The hunchback was a common theme and one that had special significance throughout Mesoamerica.

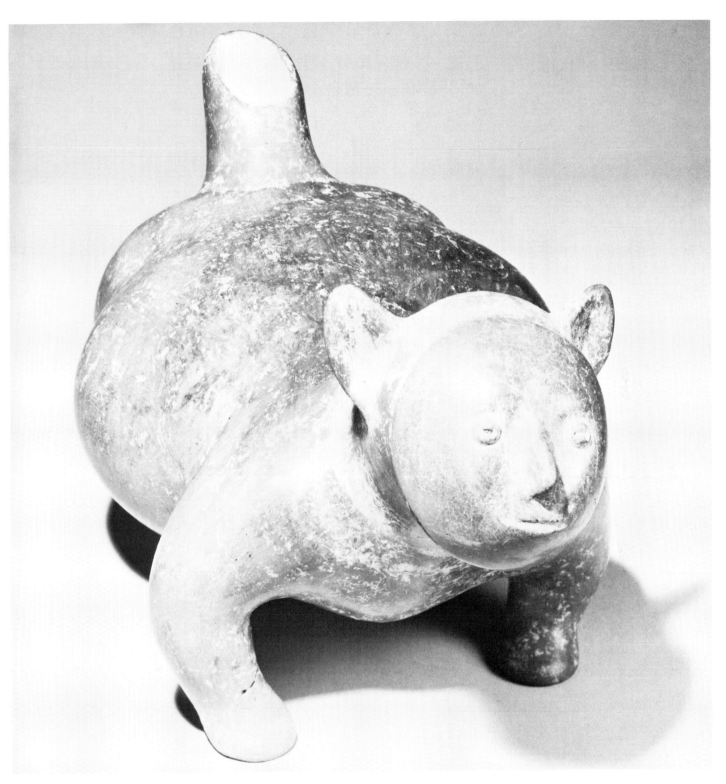

87 Dog Wearing Human Mask
Colima, West Mexico;
300 B.C.-350 A.D.
Ceramic
7-1/2 in. (19 cm.); 8-1/4 in.
(21 cm.); 15 in. (38 cm.)
Private collection

In all Colima art, this dog is the only animal portrayed with a human mask. Dogs were considered guides or companions in the underworld, and hollow clay sculptures of them were often placed with the deceased in shaft tombs. They are depicted in a variety of poses and are numerous in collections, but examples of dogs wearing human face masks are extremely rare. This masked dog is the only known example shown pregnant.

88 Tripod Vessel

Teotihuacán, Mexico;
200-400 A.D.
Ceramic, stucco, and paint
5-1/2 in. (14 cm.); 6-1/8 in.
(15.5 cm.)
Collection of Mr. and Mrs.
Charles Campbell

This stuccoed and painted
cylindrical tripod bears three
double-headed feathered serpents
between upper and lower bands
of geometric design. A sacred
burial vessel, it was found with
an undecorated orangeware bowl
and bone inside. It is painted in
red, blue, black, and white on
the exterior, with black on the
interior and legs. The vessel is a
small but beautifully rendered
example of the Teotihuacán
mural painting technique that
found larger expression on the
interior and exterior walls of
temples and apartment
compounds.

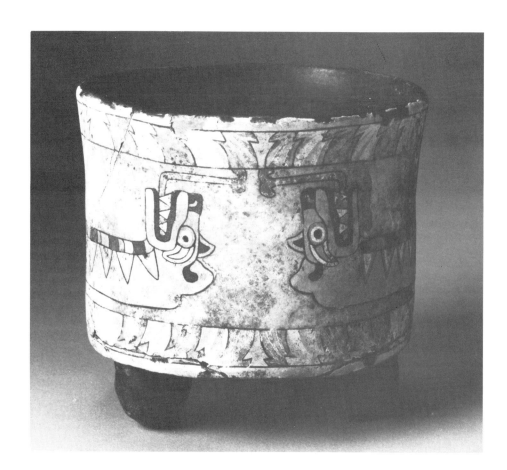

89 Stone Mask

Teotihuacán, Mexico;
200-400 A.D.
Stone and pyrite
4-3/4 in. (12 cm.); 4-1/4 in.
(11 cm.); 2 in. (5 cm.)
Private collection

Stone masks dating from the
Classic period of the Teotihuacán
empire were generally carved
with wide forehead, oval eyes,
and open mouth and were
usually devoid of any emotional
expression. This example, which
is more realistic than many,
could be a burial mask that was
once topped with a headdress of
soft materials, and it may be the
portrait of a priest-ruler or the
image of a deity. The mask is
carved of black stone, and the
eyes are inlaid with pyrite, a
mirror-like substance that has
yellowed with age.

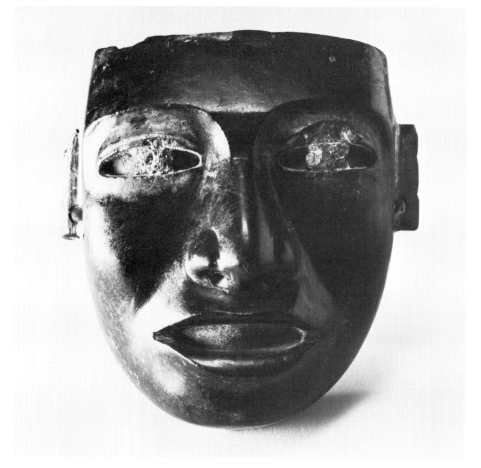

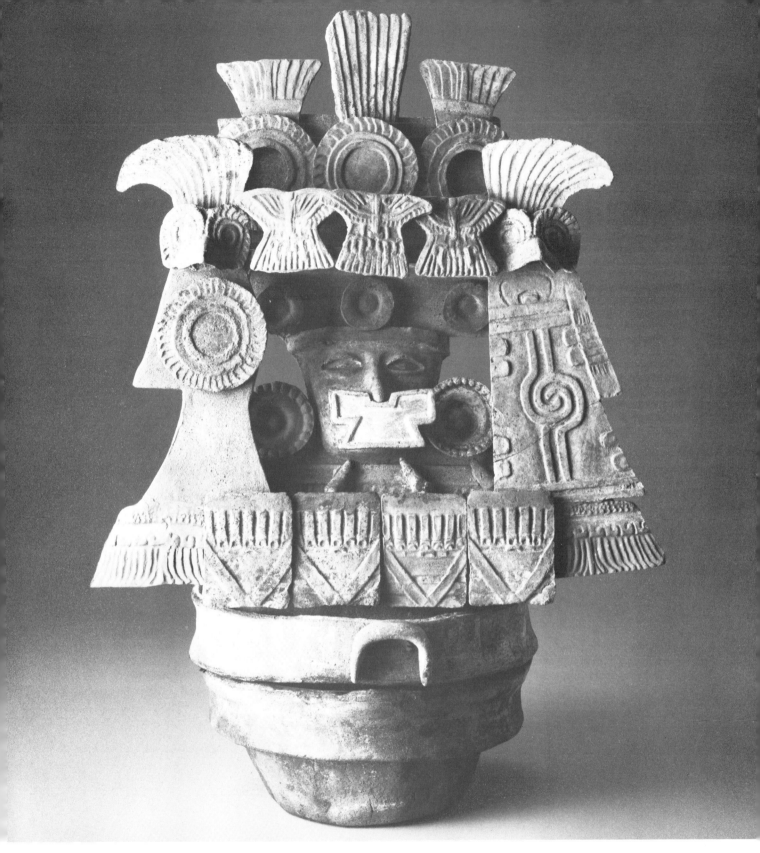

90 Two-Part Incense Burner
(Incensario)
Teotihuacán III (Early Xolapán
Phase), Mexico; 450-550 A.D.
Clay and paint
20-7/8 in. (53 cm.); 15 in.
(38 cm.); 10-1/2 in. (26.5 cm.)
Collection of Elayne Marquis

Elaborate incense burners such
as this were used for religious
ceremonials at the height of the
Teotihuacán empire. Incense
burned inside the thick-rimmed
lower bowl would rise through a
chimney opening at back, behind
the crest of the top part. The
chimney helps support the

representation of a shrine or
temple facade with a mask in the
doorway shown above. The
elements applied to the front
surface were usually mold-made.
This example is buff clay, with
yellow, white, and blue paint
applied after firing, and has
restoration on its right side.

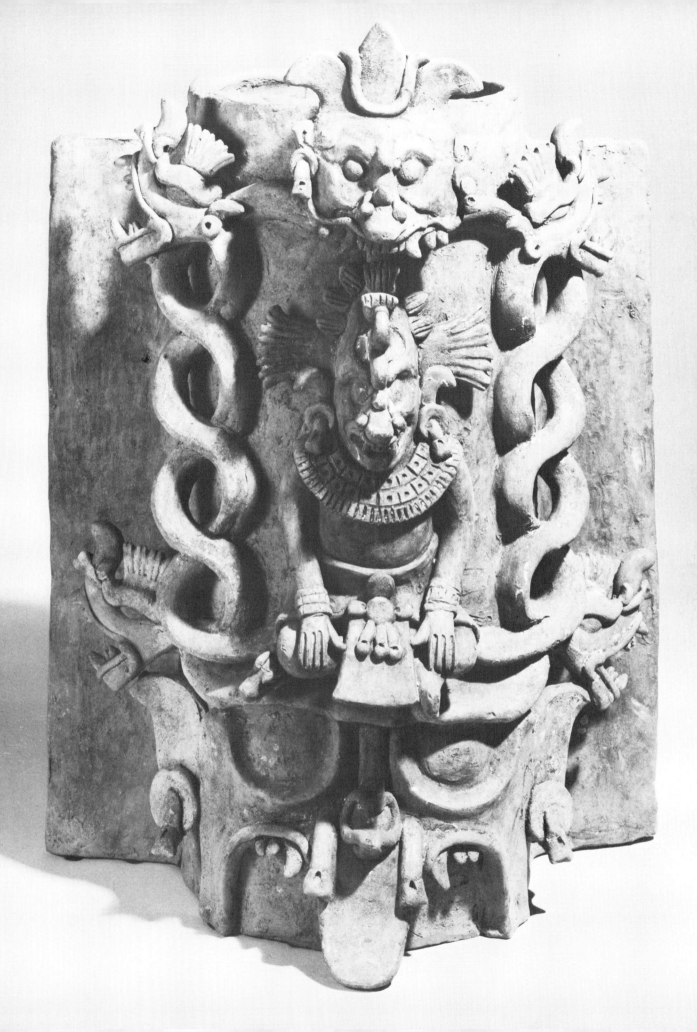

91 Flanged Cylindrical Vessel
Maya, Palenque region
of Chiapas, Mexico;
700-900 A.D.
Ceramic and paint
18 in. (45.6 cm.); 12-1/2 in.
(31.8 cm.); 9 in. (23 cm.)
Ex-coll. Jay C. Leff
Private collection

In this complex ceremonial
scene, God K (identified by his
serpent-head foot) sits
cross-legged, enthroned on the
head of a Long-Nosed Earth
Monster. On a canopy above
is the head of a Jester God
supported by flanking pairs of
entwined serpents. These
flanged vessels were
ceremonial supports for
incensarios. This piece is
unique in that it is the only
example of its type that shows
God K in a central dominant
position. It is modeled in
red-orange clay with traces of
blue-green pigment on the
serpents and the collar
of God K.

92 Male Portrait Head
Maya, Chiapas/Tabasco,
Mexico; 550-950 A.D.
Stucco and paint
8-5/8 in. (22 cm.); 6-1/2 in.
(16.5 cm.); 5-1/2 in. (14 cm.)
Private collection

This head of a royal
personage illustrates the Maya
custom of artificially
elongating the nose ridge with
adjoining forehead serrations.
Probably originally used in an
architectural context, such as
an interior palace facade, this
head is now missing its ears
and identifying headdress
ornamentation. Stucco facades
were usually brightly painted,
and this piece has traces of
color on its left cheek and
upper lip.

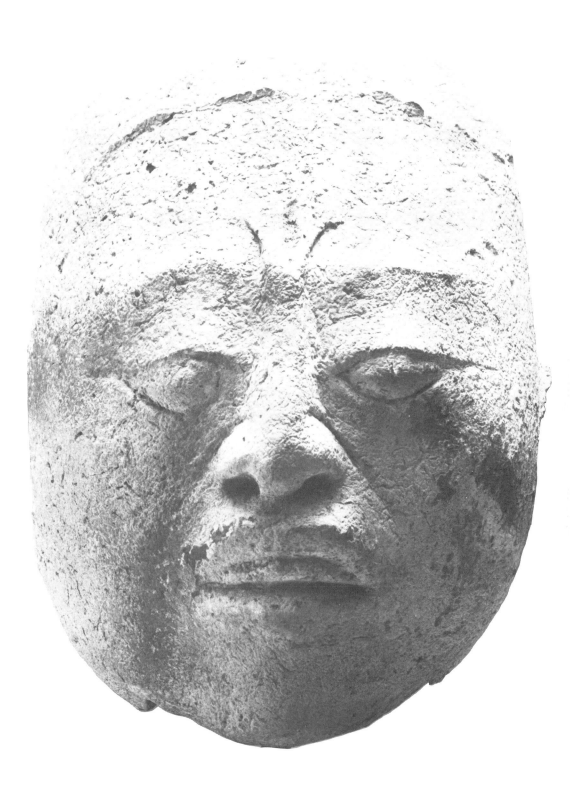

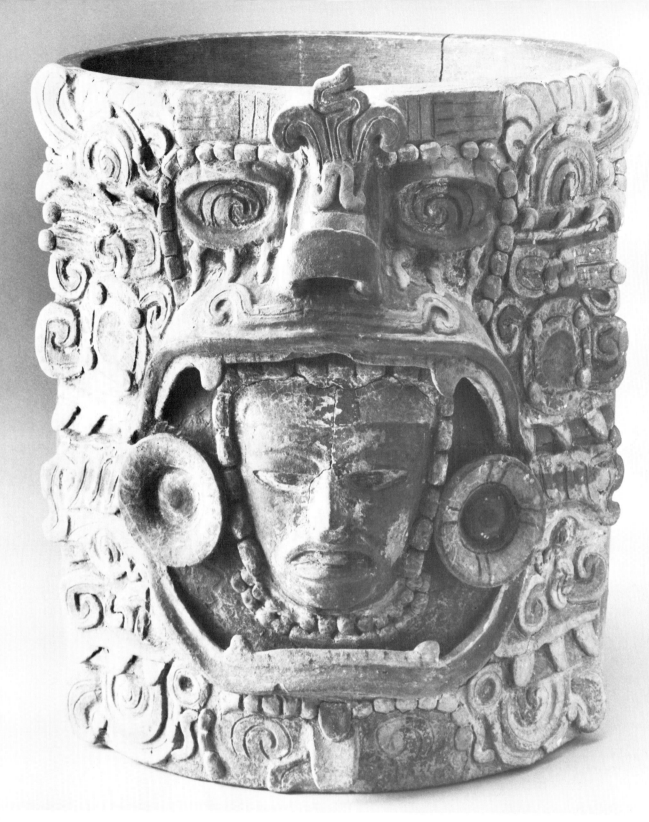

93 Container with Pastillage Decoration

Maya, Petén area of northern Guatemala; 400-600 A.D.
Ceramic and paint
12-3/4 in. (32.4 cm.); 11-2/3 in. (29.5 cm.)
Private collection

The central feature of this container is a sculptured portrait of a young Teotihuacán lord emerging from the fanged mouth of a Maya Sun-Jaguar Deity with a flame-embellished snout. The lord's face and forehead are outlined with heavy beads of jade called *chalchihuitles*, and below his chin is a double-strand choker of smaller beads. The centers of his large Teotihuacán-style spool earplugs are painted red, as is his face and the interior of the jaguar's mouth. The snouted Earth Deity appears below the jaguar's lower jaw, and its face (like that of the Sun-Jaguar Deity) is surrounded with smaller beads of jade. The pastillage decoration on both sides, which recalls the embellishment of Early Classic Maya temple facades, includes knotted bows, the quincunx sign, the entwined mat symbol, and beaked and feathered bird heads. It is interesting to note that the eyes of all the deities and birds surrounding the lord are of the same incurved type characteristic of the Maya Sun-Jaguar Deity. This container is painted in red, black, yellow, and white; there is no decoration on the back.

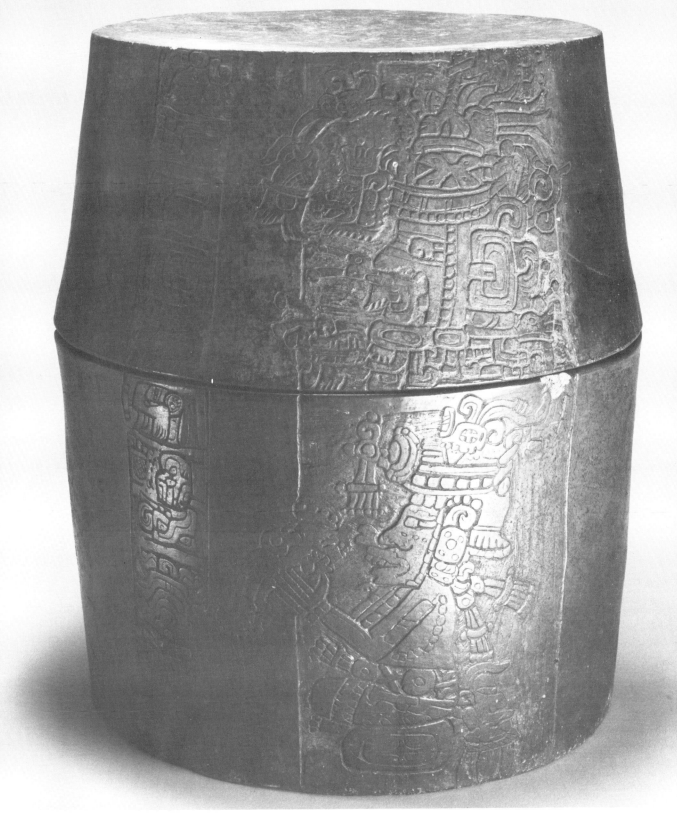

94 Two-Part Container
Maya, Petén area of northern
Guatemala; 350-400 A.D.
Ceramic and cinnabar
18 in. (45.7 cm.); 16-1/4 in.
(41.6 cm.)
Private collection

Containers such as this served as
burial urns for special items
relating to second burials or
collections of precious heirlooms.

Both portions of this container
are inscribed and carved in low
relief. Running down the left side
is a hieroglyphic text which links
contiguously both parts and
indicates a parental statement.
The principal figure, a seated
royal personage with elaborate
headdress holding an offering to

the God of Number 9, is
presumably the deceased
individual for whom this urn
was made. A heavy wash of
cinnabar was painted over a
portion of the top and the entire
carved and inscribed portion of
the upper part.

95 Carved and Incised Vessel

Maya, Petén area of northern
Guatemala; 350-550 A.D.
Ceramic
5-1/4 in. (13 cm.); 5 in.
(12.8 cm.)
Private collection

This elaborate round-sided vessel bears eight incised glyphs equally spaced around the upper band, each within its own inset cartouche. The central band of the vessel consists of two different elements: (shown above) the Waterlily Jaguar Deity who holds a human head within his wide-fanged jaws, and (on back) a stylized Long-nosed Deity with quincunx earspool and fleshless lower jaw. Each deity head is framed within a flexed pair of jaguar legs, with claws spread to the outside. Between the facing claws is a highly stylized Cauac Monster profile; three sun rays curve down below. Incised jaguar spots, glyphs, and human and animal heads appear on the flexed jaguar legs. Their placement suggests a textual relationship to the formal glyphs around the vessel's upper band. The lower band at the base is carved with alternating triangles; four vent-slits in the underside allow for greater sound from the rattling pellets concealed inside. The clay of the vessel is very thin, and the exterior surface color varies from dark brown to orange.

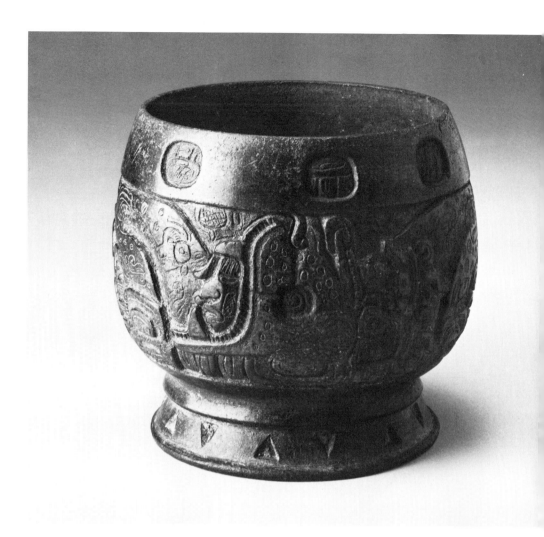

96 Seated Male Figure

Maya, Jaina, Campeche, Mexico;
550-900 A.D.
Ceramic and paint
4-1/4 in. (11 cm.); 3 in.
(7.5 cm.); 2-3/8 in. (6 cm.)
Private collection

The island of Jaina served as a burial ground for Maya aristocracy, and images of upper-class dignitaries, both male and female, were often mold-made with individual features added later. This seated dignitary with elaborate necklace, pendant, and earplugs has large, incised wristbands on both arms. The figure has touches of white on wristbands, hands, and necklace.

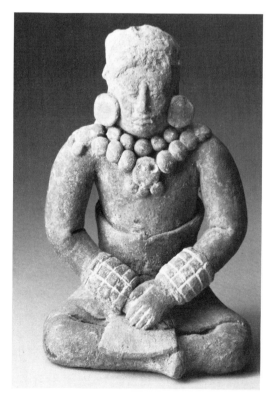
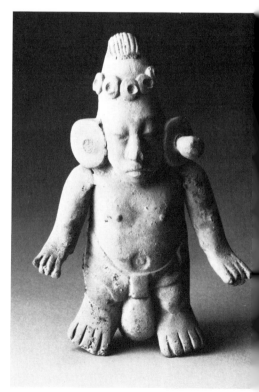

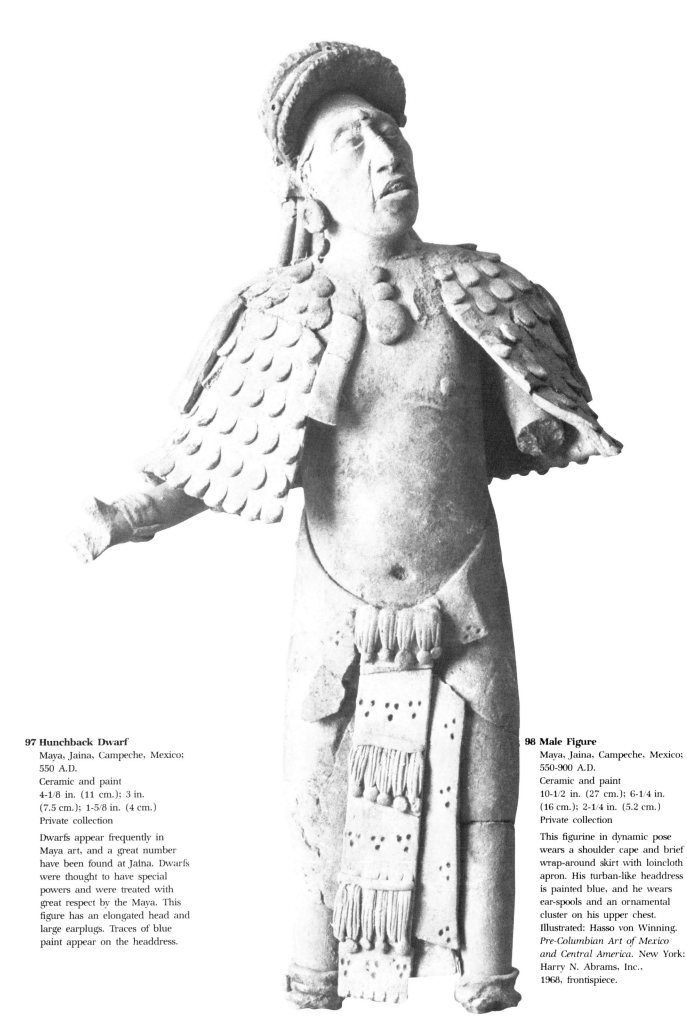

97 Hunchback Dwarf

Maya, Jaina, Campeche, Mexico;
550 A.D.
Ceramic and paint
4-1/8 in. (11 cm.); 3 in.
(7.5 cm.); 1-5/8 in. (4 cm.)
Private collection

Dwarfs appear frequently in
Maya art, and a great number
have been found at Jaina. Dwarfs
were thought to have special
powers and were treated with
great respect by the Maya. This
figure has an elongated head and
large earplugs. Traces of blue
paint appear on the headdress.

98 Male Figure

Maya, Jaina, Campeche, Mexico;
550-900 A.D.
Ceramic and paint
10-1/2 in. (27 cm.); 6-1/4 in.
(16 cm.); 2-1/4 in. (5.2 cm.)
Private collection

This figurine in dynamic pose
wears a shoulder cape and brief
wrap-around skirt with loincloth
apron. His turban-like headdress
is painted blue, and he wears
ear-spools and an ornamental
cluster on his upper chest.
Illustrated: Hasso von Winning.
*Pre-Columbian Art of Mexico
and Central America.* New York:
Harry N. Abrams, Inc.,
1968, frontispiece.

99 Standing Figure

Maya, Jaina, Campeche, Mexico;
500-900 A.D.
Ceramic and paint
9-1/4 in. (23.5 cm.); 5-1/4 in.
(13.5 cm.); 2-1/2 in. (6.5 cm.)
Private collection

This pot-bellied figure with
goatee wears a tufted or quilted
garment. The rear balancing
support has an opening so that
the figure can be blown as a
whistle. The distinctive blue
pigment called "Maya blue"
is well preserved.

100 Male Figure

Maya, Jaina, Campeche, Mexico;
550-900 A.D.
Ceramic and paint
8-1/4 in. (21 cm.); 4-1/2 in.
(11.4 cm.)
Private collection

This standing figure of a lord or
ruler wears a fan-like head
decoration which is surmounted
by a large bow with streamers
hanging down one shoulder. His
aristocratic face
is intricately decorated with
scarification and tattoos, and he
has a short, trimmed beard. The
thick choker around his neck
might also be a roll of cloth with
a large bead attached. A folded
cloth rests across his left arm
and his right arm is upraised.
He appears ready to perform an
act of ceremonial purification.
The figure has vestiges of orange,
blue, and white paint.

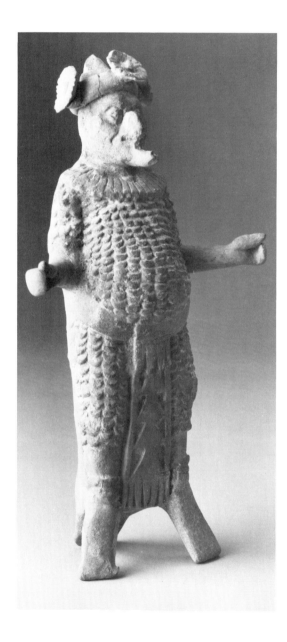

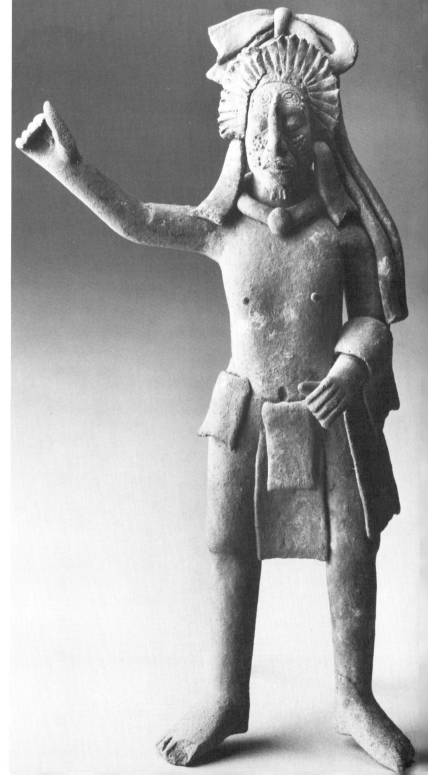

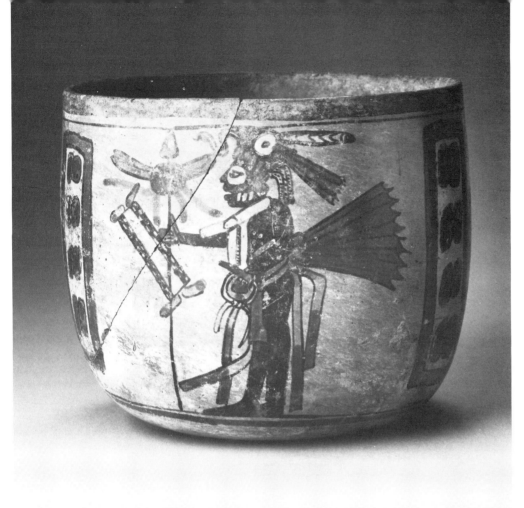

101 Bowl

Maya, Guatemala; 600-900 A.D.
Ceramic and paint
5-1/2 in. (14 cm.); 7 in.
(18 cm.)
Private collection

Three standing musicians, all
facing the same direction, adorn
this Late Classic bowl. Two of
the musicians hold frame-like
rattles (above), while the other
blows into a horn (below). All
three are dressed as warriors
with black faces and bodies,
possibly indicating that they
represent gods from the
underworld rather than living
musicians. A vertical panel of
decorative glyphs separates
each figure.

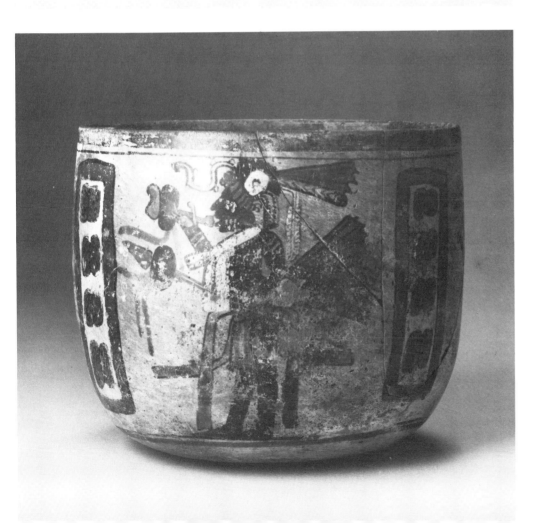

102 Tripod Plate with Warrior

Maya, Yucatán; 600-900 A.D.
Ceramic and paint
3 in. (7.5 cm.); 14-5/8 in.
(37 cm.)
Private collection

The theme of a black-hooded warrior dressed in a jaguar pelt and holding spears is one repeated on a number of Maya plates dating from the Late Classic Period. The glyphs around the rim are not meant to be read; most probably the artist copied, but did not understand, the glyphic language of the Maya. The significance of the figure remains unknown.

103 Plate with Seated Figure

Maya, Petén, Guatemala;
circa 600 A.D.
Ceramic and paint
2-3/8 in. (6 cm.); 11-1/4 in.
(28.5 cm.)
Private collection

The interior of this plate depicts a seated lord holding up a smoking offering to God K. He is seated on a jaguar throne which is a symbol of power and authority.

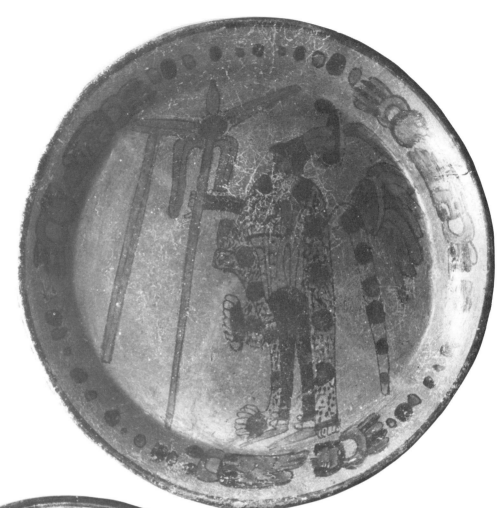

104 Male Figure

Veracruz, Mexico; 300-600 A.D.
Ceramic
33 in. (84 cm.); 21-1/2 in.
(54.5 cm.); 25 in. (63.5 cm.)
Private collection

This cross-legged figure in ritual position probably represents a young dignitary or priest, shown here with turban, earplugs and bracelets, and waistband with short, open-flapped apron. The pupils of the eyes are holes that extend through to the hollow interior of the figure; the fingernails and toes are carefully modeled. The piece is a fine example of Veracruz monumental sculpture which has close counterparts in Tierra Blanca and Acatlán de Perez Figueroa, areas adjacent to southern Veracruz.

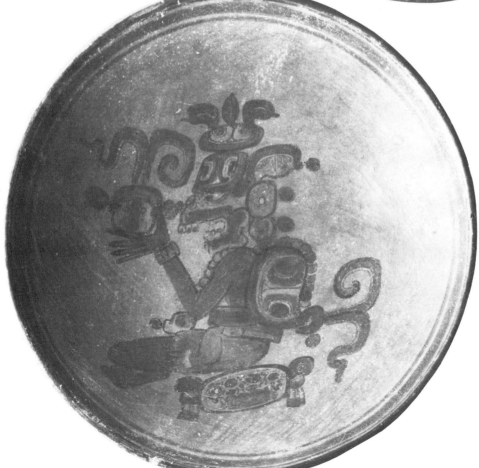

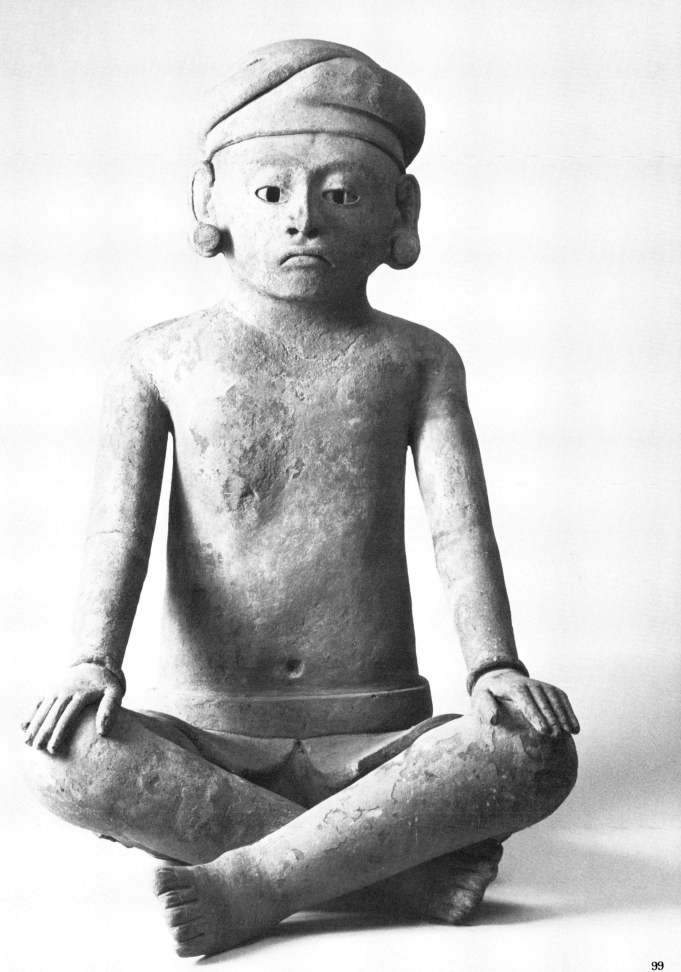

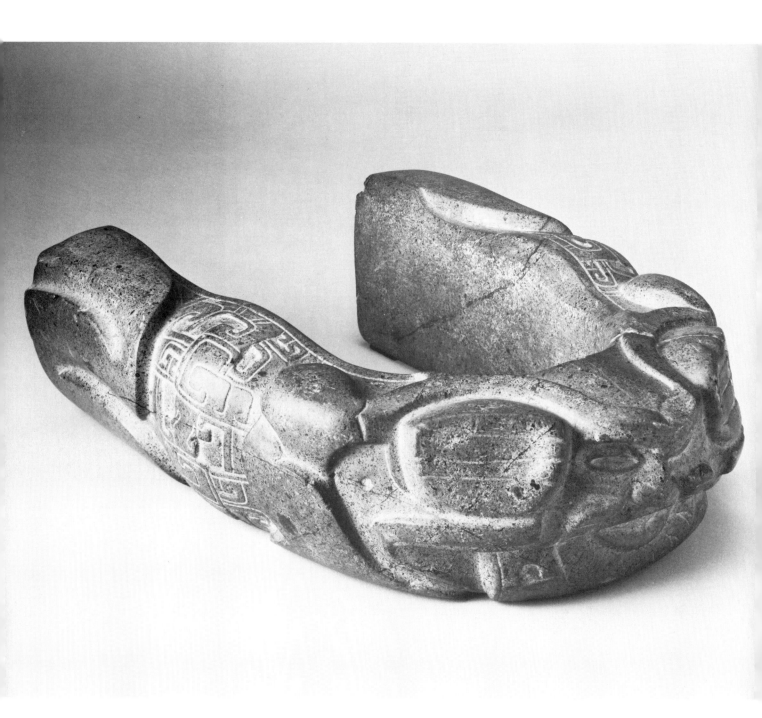

105 Yoke *(Yugo)*

Tajín, Veracruz; 600-900 A.D.
Serpentine
5-1/8 in. (13 cm.); 14-1/2 in.
(37 cm.); 16-1/2 in. (42 cm.)
Collection of Elayne Marquis

Heavy stone yokes, so called
because of their similarity to ox
or horse collars, seem to be
symbolic replicas of wooden belts
used for protection in the ritual
ball game. Many yokes have the
general form seen here; this
example represents a frog or toad
with its legs extending along
either side. A bearded human
face is carved on the curved
outer surface of the yoke, and
interlaced designs of the Classic
Veracruz style appear on the top
and outer sides.

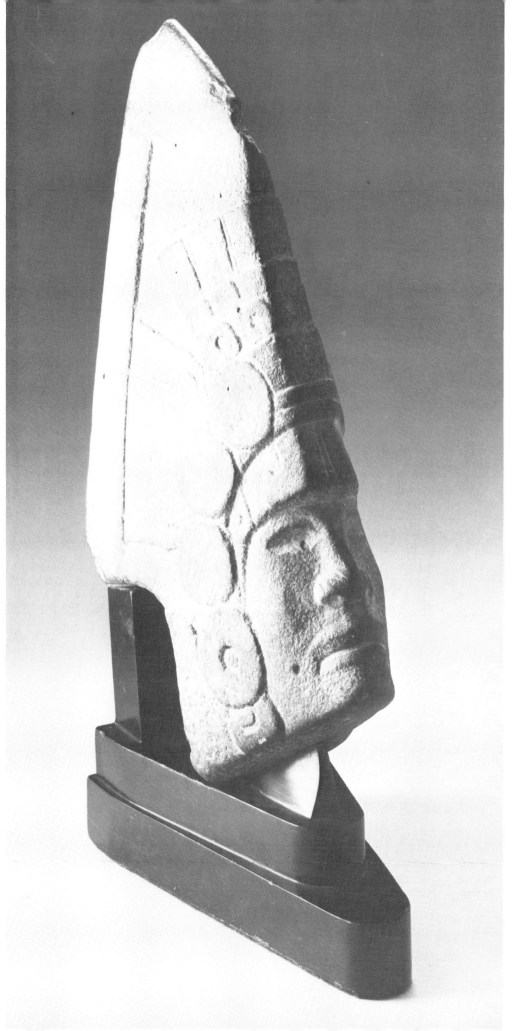

106 Hacha

Veracruz, Mexico; 600-900 A.D.
Basalt and vestiges of paint
14-3/4 in. (37.5 cm.); 4-1/2 in.
(10.8 cm.); 8 in. (20.2 cm.)
Private collection

Curious but often elegant stone
sculptures associated with the
ritual ball game were produced
frequently in Classic Veracruz.
This object is an example of an
hacha, or flat stone reminiscent
of a votive axe, that was closely
associated with the ritual ball
game. This game involving
human sacrifice was played with
a rubber ball, the players
wearing specially padded
coverings to protect their bodies.
It is thought that stone replicas of
ball-game equipment served a
commemorative purpose. The
head represented on this *hacha*
wears a headdress with
ornaments (depicting the upper
jaw, eye, and nose decoration of
an animal) that have a strong
relationship to the style
of Teotihuacán.
Illustrated: Hasso von Winning.
*Pre-Columbian Art of Mexico
and Central America.* New York:
Harry N. Abrams, Inc., 1968,
pl. 287, p. 210

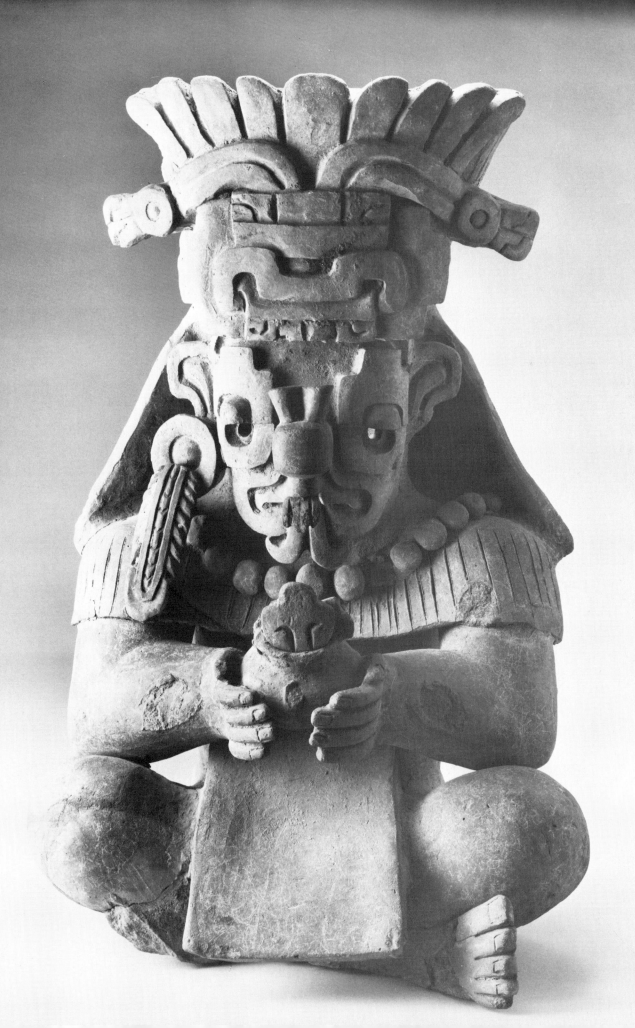

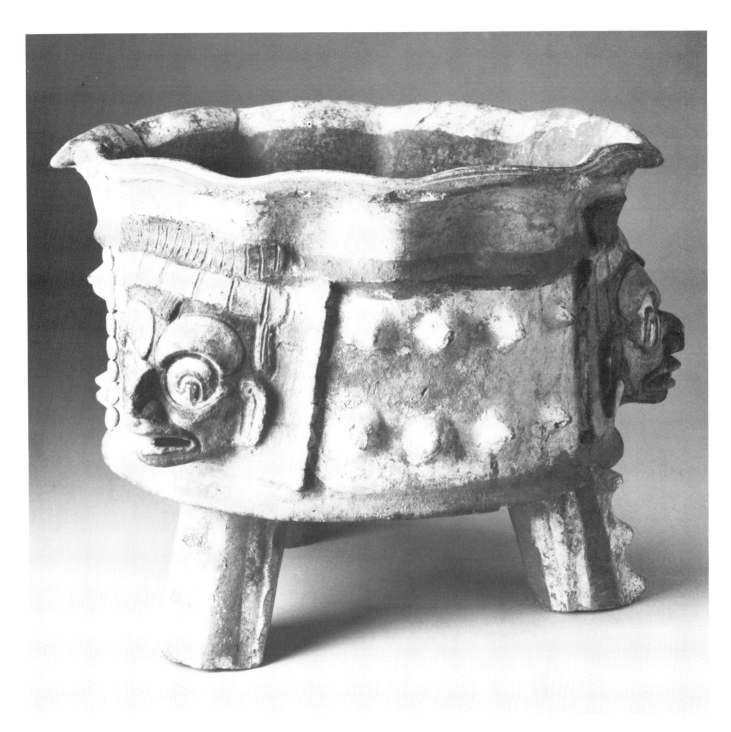

107 Funerary Urn

Zapotec, Oaxaca; 200-800 A.D.
(Epochs IIIA and IIIB)
Ceramic and paint
25-3/4 in. (65.4 cm.); 16 in.
(40.6 cm.); 13 in. (33 cm.)
Private collection

This elaborate urn depicts Cocijo, the God of Lightning and Rain, who was perhaps the most important deity of the Zapotec pantheon. Jaguar and serpent elements are combined in the figure's mask; the tassel attached to the right ear-plug may symbolize corn. Within the headdress is the "Glyph C," which is thought to be a water sign, from which issues a cloud or water symbol. The figure holds a jar in the offertory position. Most of these urns have been found arranged on tomb floors or in their antechambers. This example has remains of red pigment, which was commonly used in mortuary offerings and associated with death.

108 Tripod Effigy Vessel

Nebaj, El Quiché, Guatemala;
900-1200 A.D.
Ceramic and paint
10-1/2 in (26.6 cm.); 13-3/4 in.
(35 cm.)
Collection of Mr. and Mrs.
Charles Campbell

This effigy vessel, which probably functioned as an incense burner, bears three representations of the same bold face with aquiline nose in equidistant areas around the vessel. It is painted in blue, orange, black, red, and white. The face panels are separated by raised nodule areas which are repeated on the feet.

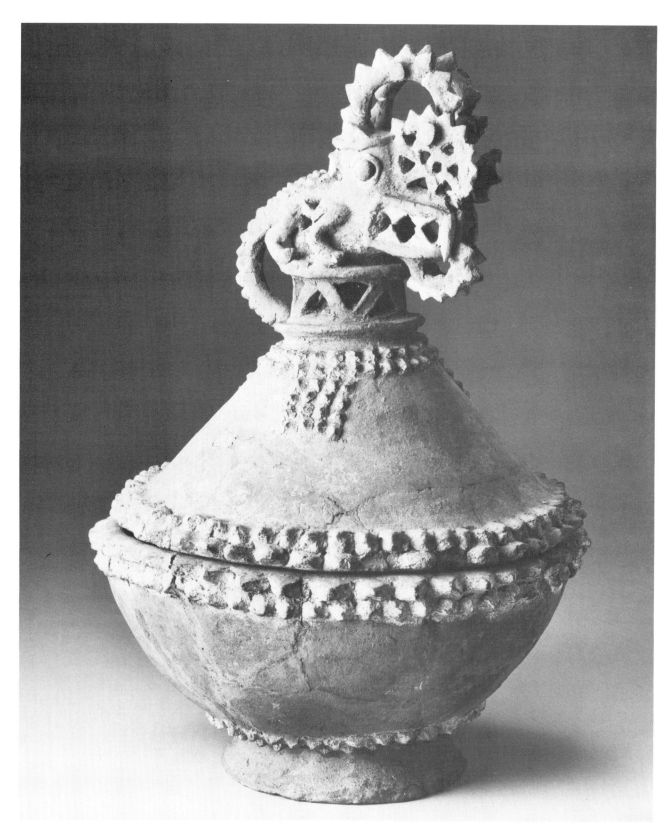

109 Two-Part Incense Burner
(Incensario)
Guanacaste, Nicoya Region,
Costa Rica; 300 A.D.
17-3/8 in. (44 cm.); 12-3/4 in.
(32.5 cm.); 12-1/4 in. (31 cm.)
Collection of Elayne Marquis

An example of what has been
termed Modeled Alligator Ware
(Type A), this elaborately
conceived incense burner with
vented lid has on the handle a
crested alligator which may have
mythological significance. The
appliqued, raised nodules on the

rims and other areas of both
parts of the vessel are probably
intended to represent alligator
hide. The entire vessel is
composed of unburnished buff
clay, with vestiges of red, white,
and blue paint.

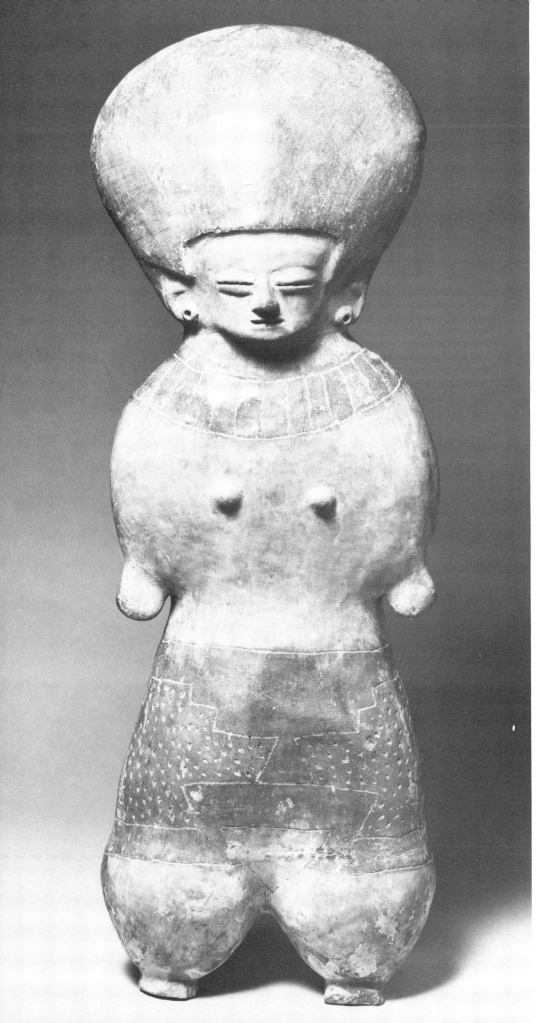

110 Female Figure

Early Manabi; Ecuador;
1500-1300 B.C.
Ceramic and paint
22-1/2 in. (61.6 cm.); 7 in.
(18 cm.)
Private collection

This large, standing, hollow female figure is superlative for her size and degree of refinement. Her face is early transitional Chorrera style, but with refined coffee-bean eyes and more realistic lips, ears, and earspools. The flattened forehead beneath the domed headdress is undoubtedly the result of artificial frontal-occipital head deformation. The incised areas beneath the neck and between the waist and legs are painted red. The incisions themselves appear to have been filled with white at one time. Prior to acquisition by the present owner, the upper portion of the head was broken and crudely glued together. During a subsequent professional repair, enough samples of the body clay were retrieved for thermoluminescence testing which yielded a date of 1300 B.C. ± 200 years.

111 Finials and Pendant
Sinú and Tairona, Colombia;
date unknown
Gold
Top left: 2-1/2 in. (6.4 cm.);
1-1/2 in. (3.8 cm.);
3 in. (7.6 cm.)
Top right: 4-1/2 in. (11.4 cm.);
3 in. (7.6 cm.); 2 in. (5 cm.)
Bottom: 2 in. (5 cm.); 1-1/2 in.
(3.8 cm.); 3 in. (7.6 cm.)
Private collection

The peoples of Colombia attached great significance to gold and were highly accomplished metallurgists. Gold ornaments served symbolic or protective purposes; they were often placed in the burials of important individuals. The two examples at top left and right are finials that may have served as tips for batons or ceremonial scepters of rank. Noteworthy for their degree of detail and open filigree work, they are characteristic of the Sinú culture of northern Colombia. The pendant immediately below, representing a crouching feline with seated bird, is an unusually refined example of a type of ornament made by the peoples of northern Colombia or Panama.

112 Pair of Ceremonial Vessels
Chimu, north coast of Peru;
12-13th century A.D.
Gold
Left: 4-5/8 in. (12 cm.);
3-1/2 in. (9 cm.)
Right: 5 in. (12.7 cm.); 3-3/4 in.
(9.5 cm.)
Private collection

Goldwork appeared in Peru as
early as the Chavín culture and
continued throughout subsequent
civilizations. The Chimu were
especially noted for their
advanced goldworking techniques
and believed gold to be a
material associated with splendor,
divine power, and the sun. These
royal vessels each depict a
standing Chimu deity who
appears to be holding a staff on
either side.

Pectoral or Diadem
Calima, Colombia; date unknown
Gold
9-1/2 in. (24.1 cm.);
11 in. (28 cm.)
Private collection

This large and magnificent
pectoral or diadem is made in
four pieces and worked in gold
foil with repoussé decoration. The
helmeted human face in high
relief at center was done in
repoussé over a stone matrix. An
H-shaped nose ornament is
suspended on wires from the
nostrils and echoes the geometric
motifs in the border decoration.
Below are two circular plaques
or ear discs, also suspended
on wires.

113 Portrait Head Bottle

Moche, north coast of Peru;
Phase IV
Ceramic and paint
9-1/2 in. (24 cm.); 6-1/8 in.
(15.5 cm); 6-1/2 in. (16.5 cm.)
Private collection

Effigy or portrait bottles such as this are remarkable examples of a realism that seems to have few parallels in the New World before the arrival of Europeans. What sparked the elements of this great interest in realism among the Moche remains obscure. Also unknown are the identities of the individuals portrayed. The example shown here has elaborate designs on his face and neck which represent either face-paint or tattoos.

114 Feather Panel

Tiahuanaco or Huari Empire,
south coast of Peru;
circa 700 A.D.
Parrot feathers, cotton base
fabric, and alpaca
32-1/2 in. (82.5 cm.); 87-3/4 in.
(233 cm.); 3/4 in. (2 cm.)
Private collection

This large and spectacular
feather panel, which probably
served as a hanging for a royal
court, is composed of four
juxtaposed turquoise and yellow
rectangles of feathers which are
sewn into a cotton-base fabric. A
cache of about ninety-six such
hangings rolled and placed in
ceramic jars were found together
in southern Peru in 1942. They
are all virtually identical; three of
them were dated by means of
radiocarbon techniques to
700 A.D.

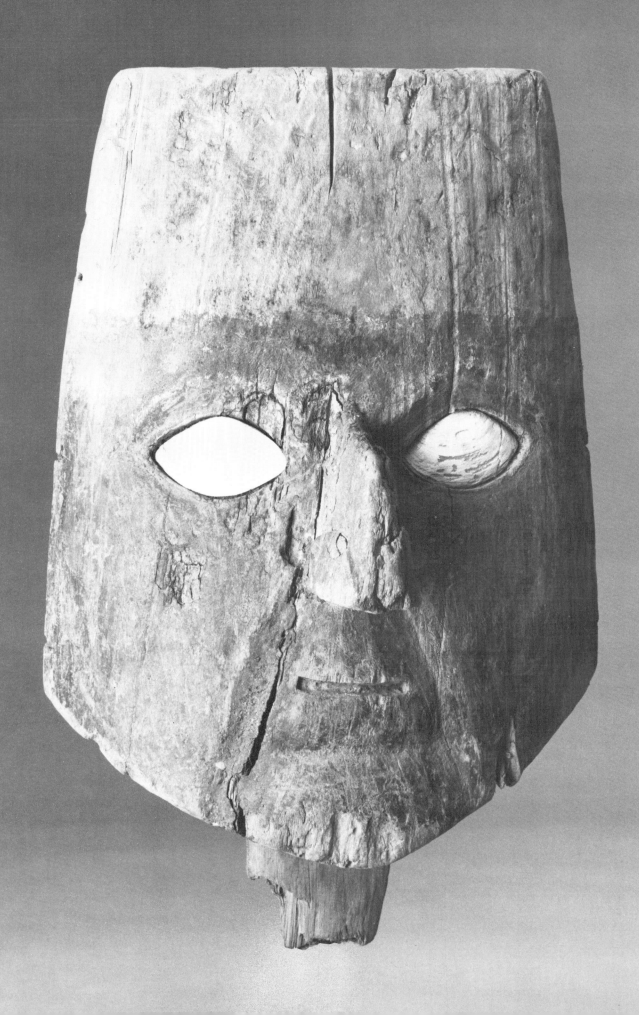

115 Burial Mask

Chancay, central coast of Peru;
1200-1450 A.D.
Wood, paint, and spondylus shell
14-3/4 in. (37.5cm.); 9-1/2 in.
(24 cm.)
Collection of Dr. and Mrs.
Ralph Spiegl

Wooden masks such as this,
lifesize and larger, were placed
over the head of a mummy
bundle, which was composed of
layers of embroidered or painted
textiles wrapped around the body.
The forehead of the mask was
frequently wrapped with one or
more headbands.

Photography:

Art Rex, Studio Thirteen, South San Francisco, California:

 Cat. nos. 1, 2, 4-57, 59-67, 72-79, 81, 85, 88,

 89, 90, 92-109, 111-115.

James Medley, San Francisco, California:

 Cat. nos. 58, 68-71, 80, 82-84, 86, 87, 91, 110.

Scott McCue, Richmond, California:

 Cat. no. 3

Designed and produced by:

 Macy's California

Printed by:

 Sapir Press, San Francisco, California

Printed on:

 Shasta Suede, 70 lb.